D1084181

A
THOMAS
HART
BENTON
MISCELLANY

A THOMAS HART BENTON MISCELLANY

Selections from His Published Opinions
1916-1960

Edited by Matthew Baigell

THE UNIVERSITY PRESS OF KANSAS
Lawrence/Manhattan/Wichita

© Copyright 1971 by the University Press of Kansas
Standard Book Number 7006-0071-X
Library of Congress Catalog Card Number 74-129075
Designed by Fritz Reiber
Printed in the United States of America

FOREWORD

Few American painters have expressed themselves as vividly as Thomas Hart Benton. For as long as he has painted, he has also written—or so it would seem—and the directness of his visual images is matched by the pungency of his verbal ones.

The articles and statements collected here give an account of Benton's developing interests as well as those attitudes of mind that have guided his artistic production. They record his early interest in Parisian modernism, his mature desire to create an American art based on national experiences, his opinions about artistic styles based on other premises, and his considered reflections upon his own painting and art in general. Depending upon his mood and subject, he may reason concisely, attack vituperatively, or respond in a down-home manner. Certain in the knowledge of his roots and heritage, he can afford the luxury of acting and reacting in whatever way he sees fit. Each of the pieces in this miscellany, therefore, adds to our total picture of the artist.

The entries are grouped into four parts which are arranged somewhat chronologically, although to sustain continuity of thought, some articles are not placed in the order in which they were written. To each part I have added an introduction, which is brief in nature so that the reader will concentrate on listening to the artist speak for himself.

Acknowledgments are made for the use of the following material:

The Whitney Museum of American Art, for The Arts of Life in America (New York, 1932).

Harper and Row Publishers, Inc., for statement in Ralph M. Pearson's Experiencing American Pictures (New York: Harper and Brothers, 1943).

New York Graphic Society Ltd., for statement in John I. H. Baur's New Art in America (Greenwich, Connecticut, 1951).

The New York Times, for an interview with Benton, February 8, 1935, © by The New York Times Company. Reprinted by permission.

Arts magazine, for Benton's Letter to the Editor of The Art Digest, February 8, 1943.

The University Review, of the University of Missouri at Kansas City, for Benton's articles "Art and Social Struggle: Reply to Rivera," The University Review, Winter, 1935; "The Year of Peril," The University Review, Spring, 1942; and "Art and Reality," The University of Kansas City Review, Spring, 1950.

The Abbott Laboratories, by whom the series The Year of Peril was commissioned.

Saturday Review, for Benton's articles "What's Holding Back American Art," The Saturday Review of Literature, December 15, 1951, copy-

right 1951 The Saturday Review Associates, Inc.; and "Painting and Propaganda Don't Mix," *The Saturday Review*, December 24, 1960, copyright 1960 Saturday Review, Inc.

I want to express my gratitude especially to Thomas Hart Benton for allowing me to include many of his articles and statements in this book and for assisting me in locating them.

Matthew Baigell

CONTENTS

TO 1917

Benton lived in France from 1908 to 1911. During those years, analytic Cubism achieved systematic definition, Fauve manipulation of color and form were further explored, and the first nonobjective paintings were created. Certainly, these were magnificent years to be alive and in Paris, but they must also have been difficult ones for Americans who were largely unprepared for the visual and intellectual shocks they found there.

For Benton the period must have been more troubling than for most artists. Born in Neosho, Missouri, in 1889, son of a U.S. Congressman and grandnephew of a U.S. Senator, Benton grew up in an atmosphere of both respect and responsibility for American institutions, politics, and destiny. The lure of European art and modern aesthetics, temptations for any young American abroad, met stiff competition from the traditions and customs Benton had already absorbed. In view of his heritage and his vast respect for it, the wonder

is not that he subsequently decided to develop an Americanist style, but that he ever chose to dally with Parisian modernism.

He did, however, both abroad and in New York, where he settled a year after his return from Paris. In 1916, he was invited to participate in one of the most important early exhibitions of modern art in America, the Forum Exhibition of Modern American Painting. Like others of his generation, he grappled with the various problems of form and subject matter that mod-

ern art presented. Unwilling to give up references to recognizable imagery, he exhibited a group of paintings based on Michelangelo's works. These he tried to render in modern form by emphasizing abstract patterning at the expense of realistic representation. He brought out shape relationships by using color as an element in his overall design rather than as a tool for literal description. His exhibition statement well reflects his modernist leanings of the moment.

STATEMENT IN *THE FORUM EXHIBITION OF MODERN AMERICAN PAINTERS*

[Anderson Gallery (New York: Hugh Kennerly, 1916)]

My experience has proved the impracticability of depending upon intellectualist formulas for guidance, and I find it therefore impossible to ally myself definitely with any particular school of aesthetics, either in its interpretative or constructive aspects.

I may speak generally of my aim as being toward the achievement of a compact, massive, and rhythmical composition of forms in which the tactile sensations of alternate bulgings and recessions shall be exactly related to the force of the line limiting the space in which these activities take place. As the idea of form cannot be grasped without mental action on the part of the beholder—as its comprehension, that is, implies the necessity of a more intense mental state than is requisite for the enjoyment of simple loveliness of color—I value its development, manipulation, et cetera, as by far the most important element entering into the construction of a work of art.

The generation of the idea of form depends upon a comparison of contoural or linear extensions, their force, direction, and the like; this generation is caused by attention to boundaries of shapes; the preeminent stimulus to realizing a cubic existence is line—therefore I make the production of interesting line relations the first business in my painting. Color I use simply to reinforce the solidity and spacial position of forms predetermined by line.

I believe the importance of drawing, of line, cannot be overestimated, because of its above-mentioned control of the idea of form, and I believe that no loveliness of color can compensate for deficiency in this respect. While considering color of secondary constructive importance, I realize, nevertheless, its value in heightening the intensity of volume, and am, to a certain extent, in accordance with all those developments which, emanating from Cézanne, tend to accentuate its functioning power.

I believe that particular attention to consistency in method is bad, and for this reason employ any means that may accentuate or lessen the emotive power of the integral parts of my work.

In conclusion I wish to say that I make no distinctions as to the value of subject matter. I believe the representation of objective forms and the presentation of abstract ideas of form to be of equal artistic value.

THE 1920's

The decade of the 1920's was the most crucial period in Benton's career. His interest in modern European art began to fade while he was employed as a draftsman at the Norfolk Naval Base in 1918. There he met rural and small-town people with whom he felt more comfortable than the New Yorkers he had come to know, and he also learned once again to appreciate the look and feel of real objects rather than colored shapes and abstract patterns. His aesthetic interests turned realistic in nature and outgoing in their concern for recording objects in the environment and for interpreting the history of the environment itself.

In 1919 he began to make a series of paintings subsequently called the American Historical Epic. It claimed his attention for the next ten years. During this period, other American artists, as Benton, found that they had drifted too far from the artistic matrix of their country, and they, too, modified their modernism or gave it up completely.

But none visualized his return to realistic styles in the same way as Benton. He consciously sought the creation of an American art based on American themes taken from the nation's past and present. In effect, he wanted to reinterpret artistically the history and experiences of the country in a contemporary and easily understood style, one that would have meaning for most people not simply because of its legibility but also because the experiences portrayed would be common ones, easily recognized.

Benton's ambition was influenced by a number of factors other than his family's heritage. He had read Hippolyte Taine's *Philosophie de l'Art* and had absorbed that author's environmentalist theories of art, according to which art production was determined by the people who made it, the period in which it was made, and the place where it was created. In short, art should grow from the needs of the people and reflect their desires and aspirations.

Such ideas were reenforced by the unlikely confluence of Benton's interest in socialist thought and his increasing dislike for Parisian modernism. He had found the Russian Revolution not a bad thing, because it held the capacity, he believed, to provide life with a decent order. Implicit in Benton's political and artistic thinking, then, was a concern for common people and for the types of lives that they led.

A particular Americanizing twist might have been given to his interests because of his friendship with Thomas Craven, who became a champion of painters such as Benton, Grant Wood, and John Steuart Curry in the 1920's, 1930's, and afterward. Undoubtedly Benton and Craven helped each other to crystallize their thoughts vis-à-vis modernist art. These might be summed up in the following way. First, they felt that an American art should develop from American sources, not European ones. Once these were explored and better understood, an American style would emerge. Second, American artists were not intellectually oriented, as were their European counterparts, and they would therefore fail in their efforts to evolve an art derived from ideas rather than one based on concrete facts, events, and experiences. Third, they believed that European modernism had exhausted itself before World War I. There could be no reason for American artists to live off art styles already a generation or two past their prime.

As a result of the mingling of ideas ranging from Taine's to Marx's to Craven's, Benton set forth on his quest to rediscover America. Within the larger patterns of American culture, he traveled in good company. A number of novelists, critics, and scholars devoted considerable portions of their lives to the redefinition and further exploration of American life. Novelists such as Sinclair Lewis and

Sherwood Anderson examined the lives led in small towns. Vernon Parrington restudied the shape and texture of American literary and intellectual history. A group of writers founded in the South a school of regionalist literature. Frederick Jackson Turner's theories concerning the influence of the frontier on the development of American democracy, although enunciated before World War I, achieved their greatest popular attention during the 1920's. And major artists such as Edward Hopper, Charles Burchfield, and Charles Sheeler found in American cities, towns, and industrial complexes an ample subject matter to explore and cultivate. The need to rediscover America in the 1920's exerted its hold on a wide range of fields—artistic, cultural, and intellectual—and Benton, as much as any other artist, helped give it a definite focus.

Among Benton's writings of the 1920's, two pieces stand out from the rest. In "Form and Subject" he revealed the changes in his outlook from his earlier Forum Exhibition statement. Now willing to recognize the necessity of subject matter as a determinant upon form, he also began to assert the necessity of developing an American subject matter. In the second article, "My American Epic in Paint," he discussed the ways in which his artistic vision translated these concerns into a mural cycle dealing with America's history.

By 1930 Benton's outlook and mature style, although subject to modification, became fixed. Each of his major mural cycles of that decade (as well as those done later) explored varying aspects of his central point of view. The murals included those done for the New School for Social Research, New York, 1930–31; the Whitney Museum of American Art (now in the New Britain, Connecticut, Museum), 1932; the State of Indiana exhibit at the Chicago World's Fair, 1933; and the Missouri State Capitol, 1936. All of the murals achieved wide publicity, the set for the Whitney Museum even being voted one of the outstanding achievements of the year by Nation magazine. They helped establish a strong interest in Regionalist painting and, to a significant extent, influenced the policies of the various governmental art programs of the depression. These programs included the visual recording of local histories, local customs, and local industries, or those experiences growing from the American environment.

In his remarks about the Whitney Museum murals, Benton elaborates on his reasons for using a certain type of subject matter. Because his murals, particularly the one painted for the State of Indiana exhibit, can be considered as painterly parallels of Turner's writings about the settlement of the various sections of the country, a short statement by Benton on that subject ends this section.

FORM AND THE SUBJECT

[*The Arts*, V (June, 1924), 303–308]

Modern painting is passing slowly through a difficult era. The overstressed importance of procedure on the one hand, and of psychological attitudes on the other, has very nearly stripped it of everything but a laboratory value.

Looking back today at Delacroix, Ingres, Courbet, and Daumier, to say nothing of the canonized Renaissance, we can well afford to question the fundamental worth of the modern artist's conception of his work. We can afford to ask whether a tablecloth and an apple, in terms of human value, are worth all the effort expended in trying to make them pictorially interesting. There are still many of us, intellectuals as well as the more emotional painters, to whom this question will seem the worst of academic reactions, and who will, by deeply ingrained habits, bring up instantly the stale reminder that "it is not what we paint but how we paint" that makes for aesthetic value. To buttress this attitude, the intellectuals can call on a very imposing mass of record from experimental psychology, and the emotionalists on an equally large, if not so learned, mass of literary appreciations and professional sympathies.

When the creative life is barren or starved, the mind tends to dignify insignificant actions with high-sounding and impressive nomenclature. With people where this kind of mental life is the rule, attention must be given to every step and every shade of emotion in order that an accumulation of details may, by its mass, offset the real futility of their concerns. America is unfortunately the home of an inordinate amount of sublimation of this order, and we see the ceremonies and the rigmarole of the Ku Kluxers and the various lodges eagerly grasped as a cover to spiritually naked lives. A spurious hurrah and mystery are the compensatory indulgences offsetting the average life of little and rather monotonous affairs. In the world of art, not only in America but also in Europe, we have a parallel condition. We have a weary pro-

fessionalism existing utterly apart from the sweep of common interests, and covering a futile endeavor with big talk or a minute and querulous concentration on details which by a healthy mind would be regarded simply as a matter of course.

The technique of modern psychology has been a boon to this state of affairs. It has lent the interest of a complicated, unstable, but growing science to a sterile artistry. It has given value, not so much to artistic creation, as to the timbre of the mental states associated with or involved therein, and it has enabled ingenious minds to pass off amusing technical exercises as revelations of the human soul. Among men of wit and culture, vanity is as salient and important a trait as with simpler people, and the temptation to explain the mystery offered by modern art has been too great for many to resist. Consequently we have numberless volumes devoted to the subject by people who have never had any creative experience of a plastic order, but who have seen the opportunity of parading their cleverness before their less gifted friends. Some of the books have been sincere; all of them, however, bear the impress of the encyclopedia and the textbook rather than of genuine thought; and without exception they have concentrated on sublimating the mechanics or psychology of processes which have been so deified as to obscure all teleological issues. These books have presented and defended the "intellectual abstractionist" and the "emotional expressionist" from the same base. They have extended the problems of psychology and pathology to the common processes of art, and have loaded the simplest factors of the craft with what is, to the uninitiated, a profound and serious significance. The result has been that the artist, overwhelmed by this evidence of his importance, has snuggled down into his rut, and has ceased to question himself. By giving a fine name to a few meticulous daubs, or simply by making the daubs, he can get into a superior class, and swamp his actual insignificance by a knowing and precious air. Form and feeling have been alternately the headlights of this new interpretive aesthetic. And form and feeling have been accepted as the watchwords of modernity in plastic expression, and have become the

indispensable shields behind which the modern artist conducts his defense against the inquisitive layman.

A specific definition of form and feeling agreeable to all writers and artists for all purposes is not to be had, but in a general way, leaving aside the technical use of form as a sculptural attribute, the terms may be defined as *mode* and *tone*. Emphasis is laid upon the one or the other according to temperamental bias. With the intellectual, the mode of presentation is important; with the expressionist, it is the tone, the all-pervading emotional element. The psychological definition of form as a unique impression of the elements of experience existing simply in awareness, is not tenable in a discussion of the formative arts; for even in the most emotional color splashing there is some ordered construction involved which calls into play very special sorts of knowledge. These have a decided effect, in expression, on the most accurately visualized mental forms, and never leave these forms in the state of their inception. We can only speak, in an article of this nature, of objectified form—form which has been given a tangible existence, capable of as complete apprehension by others as by ourselves.

Though form may be looked upon generally as a unifying factor, it is in reality something more. Objects selected for pictorial presentation may be unified, as is so often the case in Impressionistic painting, by mere veils of tone. Disparate objects may be apprehended as one, simply by being reduced to one general grade of intensity—as a photographer, by reducing and enclosing nature, makes possible an immediate perception of much variety. But this cannot rightly be called form. For real form demands an obvious imposition of will on the elements of experience. Form is a characteristic of the human mind; it has no prior existence in nature, and for a genuine form we must have something more than a mere makeshift reduction of intensities to a dead level. We must have in clear outlines the human imagination actually disposing and ordering relationships. The action of our imagination on our impressions is, of course, going on continually: we are always reconstructing the world to fit our

desires and conceptions, and this process inevitably colors all of our impressions. In fact, so far does it go that it is practically impossible to recall any given experience. But this unconscious activity is not enough for the formative arts. Some conception of purpose and definite ideas of sequence are necessary to give our creations a clear form.

Now this last, in spite of all that is claimed by modern artists and their psychological backers, involves a degree of very conscious work during the period of execution. The most highly emotional response to some fact of experience is certain to have its edge replaced in the technique of expression by a concern with media. There is consequently no really true expression of experience—there is always bound to be more or less deliberation about the disposal of those elements of experience which motivated the desire to express and, beyond that, the problem of establishing an alliance between that disposal and the medium in which it is finally presented. We have to decide, that is, what is important and then how to orientate our medium so that this importance will be felt. No mere disposition in the mind will serve to establish such an alliance. For instance, one may decide that a straight line is needed in a certain part of a picture, but until the line is actually in the picture its real value can never be determined. Lines are part of the painter's media, having laws of their own and affecting one another to an incredible degree. The optical illusions resulting from linear juxtapositions are well enough known to make this fact immediately apparent. Furthermore, masses, planes, and color-spots have this same faculty of affecting one another, so that it may readily be seen that the direct transfer of emotions from experience to an artistic creation is an impossibility. The mental attitude with which an artist commences even a sketch is not the same as the attitude attending the finished drawing. The nature of lines, planes, and colors in combination is too insistent to allow of so simple a thing as the pure representation of a feeling.

Among a great body of modern painters the belief in direct transfers has become a dominant superstition, and hundreds of

quite senseless daubs are glorified on the ground that they represent what the artist felt before experience. The truth of the matter is that they generally represent nothing more than a whimsical delight in the peculiarities of media, and in many respects are not so serious as the work of a seven-year-old child who at least draws with a descriptive purpose. The child's interest in giants, trains, battleships, fairies, and other real things is held to the end of his expression, and his medium, no matter how recalcitrant, is driven for his subject's and not for its own sake.

With the mature artist, however, more aesthetic interests come in, not only in the media of expression but in the very appreciation of a motif, and quite unconsciously he begins to approach life with his experience in procedure in the very front of his consciousness. He looks for motifs allowing for the use of combinations which he has found to be attractive, runs swiftly into the rut of repetition, and varies his expressions simply by changing the proportions of his shapes. He becomes like the cuckoo in the clock for whom quantity constitutes the only variation in expression. The true character of this preoccupation with media he attempts to ignore, and he obscures ideas of purpose and sequence, which have become almost entirely technical, by pretending that they reflect his experience. In this way his field becomes narrower and narrower, and we have today an astonishing array of mere still-life painters purporting to carry on the values of creative art. The giants of the seven-year-old child and the fierce engine which draws the train by the station have become, in the hands of modernity, of no more value than the kitchen pots and pans. Even man himself is treated as a piece of still life—indeed there are painters who take pride in the fact that they see no more in the growth of humanity than in a pot of flowers.

All of this is rapidly passing. Painters will certainly realize that what their psychological backers defend as a simple and laudatory naturalism is in reality but a victory of minute technical matters over the creative spirit. And they are going to see that

the very form on which they lay so much stress is one of the main sufferers from their attitude.

The connection between form and subject is far more vital than is commonly supposed. The first step to an acceptance of this fact lies in recognizing the true character of the relation between artistic form and experience, lies in seeing that significance in form can never be merely a transfer of the meaning of experience to an object. The elements of an art object and those of experience are vastly different. The elements involved in constructing an object—lines, colors, planes, et cetera—have characteristics radically different from those which they possess in our perceptions of nature. As constructive items they are first of all abstract, secondly, they are controllable, and further, they can be seen and judged in isolation if need be. Though these lines, planes, et cetera, exist in nature, they have no such independence —it is only by a conscious analytical act that they can be made to assume any innate importance, and this act deadens the emotional intensity which makes our contacts with nature significant. To see nature is never in any sense of the word to construct a picture. One may enclose a scene like the photographer, print it very prettily, and call it a fine name, but it remains just the same a piece of nature and not a work of art. It may be a picture, but never a creation having value as a form beyond the mind of its maker. Its significance, furthermore, must inevitably be merely associative.

The artist cannot hope to transfer a meaning of direct experience to lines, tones, colors, and planes; he must create a new meaning, taking into account the natural characteristics of his constructive elements in combination. And this is exactly what he does, even though he blindly believes, or affects to believe, he is presenting a bona-fide original experience. This meaning he constructs, this new thing which he gives the world, has no parallel in nature; it cannot really represent direct experiences or emotions, but it is, nevertheless, the child of both these psychic factors in that it is experience and emotion, which have by accumulation formed the temper of his mind. The character of his

conceptions is dictated by the quality and variety of his experience, and though his creations never reproduce his emotions before nature, they do reflect his general emotional tendencies. His creative meanings are therefore derived only indirectly from his contacts. They are a combination of immediate constructive needs and impulses and those habitual preferences and desires which come from the whole mass of emotional experience. To this also may be added the effect of knowledge and habits of reflection.

The poetry of a tree painted by Ryder or Courbet is not the result of a single perception of nature but of long-acquired habits of mind plus certain insistent problems of construction. Now one great fault of the modern artist lies in his denial of this dual nature of the creative act. On one side the "emotional expressionists" insist on the necessity of direct contacts and instantaneous expression, and on the other the intellectuals stress the unique value of processes which they generally dignify by the name of form. The one sacrifices all precise design, and the other all meaning; both overlook the fact that in limiting themselves to subjects of small import, they are limiting not only the appeal of their art but the very character of their forms. Once it is realized that expression can never reproduce the emotional intensities of direct experience and that form-construction is—whether we wish it or not—an affair of long-accumulated habits, it will readily be seen that art will gain by more reflection on the value of the meanings it creates. It will be better to do away with the superstition about the danger of illustration, subject-painting, and the other bugaboos of modernity. It is not necessary to sit before a still life to produce a genuine form—forms come from the mind, and the further one is from direct contact with objects, the more freedom has the mind to consider the nature of its product. Experience should be regarded simply as a field of material and not as a dictator. Emotions are often quite as strong when they arise from the combinations of the imagination as they are in the field of reality, and we have the fine poetic art of Blake as evidence of how much can be done with scarcely any dependence, in the

technique of creation, on external impressions. Today the fear of being anecdotal, together with the naturalistic interests which have overflowed from philosophy, make the artist fearful of leaving a visible model—of being imaginative. But this insistence on remaining in direct contact with a limited objectivity has not kept him from feeling a poverty in his creations. Still lifes and their geometrical counterparts, which are equally poor in meaning, are dignified by cryptic and high-sounding titles and explanations—an endeavor is made to project meaning into a totally empty vehicle. The failure to do this for public satisfaction has led to the enormous amount of obscure and futile aesthetics now on the market.

We do not need any more interpretative and psychological aesthetics. It is far better for the critic to speak and write like Taine, or for that matter like Ruskin, than to dull the edge of endeavor by sublimating such unimportant questions as the state of an artist's mind before an apple, a piece of silk, and a couple of pretty colors. This stuff does not matter. Giotto brought St. Francis to us, and through him magnificent designs, without the need of any precious intellectualism. A complex and interesting subject brought a form to suit it. The naturalistic bent of Impressionism, and certainly the movements following it, have unquestionably been salutary—they have rescued us from a stale and overornate classicism as well as opened up new vistas. But the main issues of these movements are dead, and Cézanne, Renoir, and their followers have nothing further to give us. They are artists, fine artists, but they are out of it in so far as their tendencies are influential to growth for the youth of today. In place of their interests, legitimate enough for their time, larger conceptions must come—and are coming. Painters will run to more compelling themes, and these will demand a more studied organization of pictorial elements, that is, a better and more intense form. The evasions of the abstractionist cannot stand the test of the need for clear meanings. No cryptic idiosyncrasy will be excused in the name of feeling. The artist will be forced to exercise the fundamentals of his craft, and though pretty painting

will always be an asset, it will not be the all-in-all of art as the current contempt for purpose and meaning has made it.

A revival of interest in subject will get the artist out of his narrow Bohemianism, may possibly in time make him part of the world, which, heaven knows! is justified in its indifference to his concern with napkins and vegetables, and certainly will start going a finer compositional activity than we have today. America offers more possibilities in the field of theme to her artists than any country in the world, and it is high time that native painters quit emulating our collectors by playing the weathercock to European breezes.

MY AMERICAN EPIC IN PAINT

[*Creative Arts*, III (December, 1928), xxxi–xxxvi]

In an editorial in the October issue of this magazine, Lee Simonson contrasts a set of historical murals, representing the beginning of American civilization, with a number of less ambitiously designed pictures of the American world with which I have actually rubbed shoulders, and finds the lesser effort superior to the larger. The difficulty of making a theoretic defense of my historical conceptions or of the kind of knowledge on which they are based is enhanced by the fact that Mr. Simonson anticipates my practical program in so encouraging a way as to disarm me. If I quarrel with him, it will seem to be for telling me I am fitted to do just what I intend to do.

When in 1919–20 I found myself growing out of my modern contempt for subject into a painter of histories, the question of the validity of my knowledge and interest did not occasion me any difficulty. I was too occupied with the discovery that what for me constituted an equivalent in painting for the ponderable world of experience could carry a specific human meaning. I was

a child of that period when the painters of the modern world, seeking the "essentials" of their art, had cut off from all representation and isolated it in an abstraction. I was as naïvely belligerent in those days as anyone, though in actual practice I couldn't compare with my associates whom I desperately envied. My painting capacities—never fluent in the best of circumstances—and my theoretic development as an abstractionist were frustrated by a secret interest in objects and especially figures, as such, and, further, by a tenacious notion that if I wanted a real space in my pictures I would have to use real objects to get it. The ground I stood on was very poor logically, for I accepted the modern contention that painting was an abstraction from life and not a representation in the old sense of the word. But the idea that the further you abstracted, the purer and more functionally adaptable became your forms, while logically demonstrable, would not go down and stay with me. My stubbornness on this subject kept me out of the real current of the movement, and I remember, on my return from France, how very lonely I used to feel in Stieglitz's "291," where others were practicing that to which I could only give an argumentative lip service.[1] Later I was deeply antagonized to discover that cryptic significances were being attached to these modern abstractions. The horse sense that still remained to a Missouri lawyer's son after five years of art revolted, and I began to wonder why, logic or no logic, I should continue to try getting representative meanings out of my art if I was going to put mystical ones in. I know a little more now about the vagaries of the human mind and have learned to accept as normal much that was to me then outrageous.

In 1918 I was sent to Norfolk and adjacent naval points, where I got interested in the stuff of war. This was the first genuine contact I had yet made as an artist with the actual things of the modern world. Unfortunately, I was not ready for the

[1]Alfred Stieglitz, the photographer who presided over the Little Gallery of the Photo-Secession at 291 Fifth Avenue, New York, from 1905 to 1917, was an instrumental figure in bringing modern art to America.

exciting brutalities of that time. The form I wanted was deep, equivalent to the extensive experience one has of the real world. The technique of getting that depth, as a mechanical process, I had been studying a long time, motivated partly, I must admit, by a desire to undo the theories of the abstractionists. But the need of the form itself was real. That need was, of course, not just a simple one of volume and extent but was complicated by further needs pertaining to design, which was my modern inheritance and which was intensified by researches in the history of painting. With figure attitudes and form suites borrowed from the paintings of the High Renaissance, I was able to approach at times a rhythmical structure in deep space. But I couldn't do it with things which had an insistent meaning of their own. And I couldn't give up my notions of deep space for these meanings or the patterns they might be expressed in, because that space had become the very core of my dream of an art that might be inclusive of all the conditions of reality. I felt the importance of that space in our real world, but I also recognized how much our accumulated knowledge about it conditioned our seeing it and how much our technical habits conditioned our presenting it. I knew that the innocent eye that William James speaks of as a desideratum was an impossibility and that, were it possible, our manual habits would nullify it. I wasn't simple enough (or inspired enough) just to be an artist and sustain my creative activities on my impulses. And I know that I never will be.

To apprehend the world we live in as three-dimensional is easy and natural, but to construct something on a flat surface which is genuinely its equivalent and not merely a suggestion is not. It calls for a complex technical procedure which, on analysis, seems the very negation of spontaneous Art. And there are no formulas to grease the way and make each successive effort simpler.

The murals Mr. Simonson speaks of were started in 1920 and worked on for five years, not steadily, because I worked on other more modern subjects at the same time. But the modern subjects had no insistent content and failed to deliver me from

the habits I had formed while studying Renaissance forms. Then it occurred to me that by shifting the historical content slowly upwards towards the present, the historical material, if adequately represented, would cause the form itself to change and I might learn to build a deep world out of shapes that were significant in their own right. I thought I might finally free myself and handle the modern world in the technique of a spatial realism through an epical progression. It was really then, from dissatisfaction rather than inspiration or conviction, that my conception of an American historical epic grew. But it did grow, and from a means it has become an end. And the technique itself I now see as a possible function of modern architecture.

This brings me to the validity of my interest in historical painting and the reality of my knowledge. To attempt to treat this question in the form of a logically ordered case would involve some patent rationalization. The only thing that will stand objective scrutiny is the plain fact that I started painting histories when such things were anathema in the world I lived in. And that I started painting American histories rather than Greek or Roman or biblical ones.

I was raised in an atmosphere of violent political opinions, exploded when the Democrats of the East and West were at odds over President Cleveland's policies. I was in the habit of hearing these opinions bolstered by views of historical fact. This was always going on at the dinner table, where there was always company; and though it didn't have meaning for me in a political sense, it did have significance of an emotional sort. Grover Cleveland, Indian lands, Senator Vest, Eastern bankers, railway rights, and, later, Free Silver 16-to-1 were mysterious but real factors in a real world of bewhiskered toddy- and julep-drinking men who linked this up with a real past.

Furthermore, I was raised in a southwest Missouri town when the section reverberated with the great Oklahoma rushes. We always went hunting and fishing down in what was then Indian Territory (the part of Oklahoma adjacent to Missouri), and I learned to wonder why those fellows with braided hair, dirty

pants, and calico shirts were wrongly occupying more good lands than they could use! The Senecas used to come up on the Fourth of July and give a green-corn dance in my home town, yelling and beating on drums and getting drunk and jailed. They all knew my father, for Indian law suits were constant. I went to innumerable old-settlers' and soldiers' reunions. My father, a veteran himself, was proud to parade his first son and always took me with him on his speaking trips over the rough red clay roads of the Missouri hills. And I was on the go a good part of the time after I was four years old. I heard a lot of hot stuff which the old boys thought I didn't understand. The Civil War was not a far-off thing to these old men but a living reality, and it was such to me who listened—for what did I know of time? General Forrest and his cavalry were still charging around Tennessee, and the gray coats were still digging the wilderness of Arkansas for lead veins in spite of the rifles of lonely hill-billies who had no sympathy with "aristocrats" and owners of labor. I know what camp meetings are, and political rallies of the backwoods, barbecues, schoolhouse dances (with a jug in the bush), and I know—as well as I know the skyscrapers of New York, or better—what men look like who break new land. The stuff I soaked in, listening to my father's political constituents and to old Union soldiers laying out their pension claims, is vague emotional stuff, but it lights up the historical fact on which I base the progressions of the epic I have started.

In view of the foregoing, where do my living contacts end as they go back into history? What happened in Oklahoma in my lifetime happened in Missouri in my father's and in Kentucky and Tennessee in my grandfather's; and living words from people, not books, have linked them up in feeling and established their essential sameness. What constitutes the real break in this historical progression is the machine, and I can almost fill that gap in direct experience, for I have ridden on, and well remember, the wood-burning locomotive that used to thump over the old split-log railway in southwest Missouri.

This is all I can say, without writing a book, in defense of

my "knowing about." Nor does that question really seem a difficulty. The job for me is how, using the precise and involved technique of deep space composition (which is, for me, synonymous with a complete realism), I can order my recessions of form so that they really carry my content and are not mere suites of objects with a name appended. This occurred to me when I first began to work on the subject, but it was not until 1924, when during the illness that preceded my father's death I went back to Missouri, that I got the idea of collecting individual and characteristic forms from life and using them with as little change as possible for form units in my histories. The things Mr. Simonson likes were the first efforts to give this material the sort of form that could be used in a deep-space picture. I do not doubt they are more representatively alive than the units of the first historical set, which is the only one of the three completed that Mr. Simonson has ever seen. But they are, after all, in view of my general conception, only isolated units and not organic parts of a complete realistic world. The lesser units of the murals, even of the first set, are still more important to me, because they function (though woodenly, perhaps) in a world that is fairly equivalent in its spatial structure to the real world and which will be—if I am able to do what I set out to do—a genuine world also in its context.

THE ARTS OF LIFE IN AMERICA

[Statement accompanying murals (New York: The Whitney Museum of American Art, 1932)]

The name of a picture, like the name of a person or a book, does not reveal its significance or even remotely indicate the combination of factors which constitute the reality beyond the name. Names are tags which enable us to roughly locate and

separate things. It is easy to forget this fact and to assume that in naming a thing we also know it; likewise it is easy to allow a name to take the place of a thing and to set up our judgments on verbal suggestion alone.

The subject matter of this Whitney Museum wall painting is named "The Arts of Life in America," in contrast to those specialized arts which the museum harbors and which are the outcome of special conditioning and professional direction. The tag is not accurate. On the one hand, it is not inclusive enough, and on the other, a point or two would have to be stretched to consider as arts some of the things represented. The "arts of life" are the popular arts and are generally undisciplined. They run into pure, unreflective play. People indulge in personal display; they drink, sing, dance, pitch horseshoes, get religion, and even set up opinions as the spirit moves them.

These popular outpourings have a sort of pulse, a go and come, a rhythm; and all are expressions—indirectly, assertions of value. They are undisciplined, uncritical, and generally deficient in technical means; but they are arts just the same. They fit the definition of art as "objectification of emotion" quite as well as more cultivated forms.

But the key to the meaning of this work cannot be found in its name. "The Arts of Life in America" is only a tag hung on American doings which I have found interesting. I have seen in the flesh everything represented except the Indian sticking the buffalo. That instance of romantic indulgence is a hangover from Cooper, Buffalo Bill, and the dime novels, as in truth is the spirit of the whole panel on Indian arts. One does not have to be a boy scout to understand and forgive this—through romance we Americans provide compensation for what we actually have done to the Indian.

The great painters of the Renaissance in the service of the Church built their pictures around names of religious significance. They started out with a name; and suggestion, in so far as religious meaning was concerned, finished the job. Actually the real subject matter of these paintings was given by the life, char-

acter, and environment of the period. Depending upon the painter's habitation, Mary, the mother of God, was a Roman, a Venetian, a Florentine, or a Flemish belle, and the Holy City was architecturally consistent with the local type. The saints were perfectly good people; the feminine characters—generally mistresses of the moment—more or less good; and even the grass and the sky and the landscape revealed local characteristics. The religious art of the Renaissance pictured the life of the Renaissance. The same may be said of all religious arts except possibly the Byzantine, where a difficult technique set up a representational formula. I mention all this mainly for those who have notions about the traditional dignity of mural art.

There is precedent for taking the Arts of Life seriously. It deals, as do the great religious paintings, in spite of their names, with things found in an artist's direct experience. If religious associations are considered essential, then by reversing the usual naming process, that is, by going from the picture itself toward a name, possibly the serious person may discover in the local pursuits here represented the peculiar nature of the American brand of spirituality. Going further, he or she may find a profounder label than mine and make of this mural also a religious work! But all this is still a little apart from the question of real subject in the work at hand. The "life of the time" is itself just another name, a tag which allows us to pigeonhole things conveniently.

The real subject of this work is, in the final analysis, a conglomerate of things experienced in America: the subject is a pair of pants, a hand, a face, a gesture, some physical revelation of intention, a sound, even a song. The real subject is what an individual has known and felt about things encountered in a real world of real people and actual doings.

But even this final subject matter is not pure; this work is not a mere record of experience—of facts seen, selected, and recorded. Many other things must enter as conditioning elements before experience is transmitted by art. These other things are responsible for the form of this mural, and some comprehension

of their nature is necessary before the work can be grasped in its entirety.

When we list the arts, we speak of painting as a visual art. We connect it with the act of seeing, but we are liable to forget all that the act entails.

Before the advent of the camera, the notion of independent vision, to which William James gave the name of the "innocent eye," was unknown; and painting and drawing, like other forms of significant action, proceeded from knowledge. An artist's representation of a thing was plainly affected by all of his previous experience. He did not know things by the eye alone but by and through touch, use, and other conditioning factors. That, of course, is the way he still knows things, if he knows them at all. But a shortcut has arisen which enables him to present an appearance of things about which he knows nothing. That shortcut is the trick of photographic rendition—the recording of a retinal image.

The idea that an artist could rely on pure visual impression had no existence before the invention of the camera. Seeing was not separated from its conditioning accompaniments until a "seeing" instrument was invented which was untouched by the automatic entrance of memory. Representation, before the camera supplied a shortcut, necessarily involved knowledge of the things represented. And with knowledge went meaning.

Many notions about the nature of expression which have grown up with the use of the camera will have to be abandoned before we can regain an understanding of the art of painting as it has been historically practiced, before we can again approach it as a correlation of things known rather than as a slit opened on appearances.

The phrase "correlation of things known" is open to misinterpretation, and I must make it clear that the meaning of art arising from such correlation has no connection with scientific truth. The painter's meaning is based upon direct knowledge, but the relations he sets up between things reach out, not to-

wards truth in the scientific sense, but towards a conception of propriety in relationships.

The return of modern painters to a primitive stylization indicates a realization of the necessary dependence of satisfactory form on knowledge. This return grew out of a revolt against the effort to tie the painting business to that mechanical rendition of appearance familiarized by the camera. But it also has deeper implications.

Painters, as a whole, have been at the mercy in late years of a good deal of merely ingenious phraseology. What they have accepted and said in explanation of their explorations has been frequently obscure—a mere verbal play on irrelevant and inaccurate naming.

The confusion of the notion of "visual innocence" with primitive and childlike directness has resulted from just such looseness. It is assumed that the child and the primitive are without knowledge, that they merely react to impressions, and that the straightforwardness of their forms comes from an unconditioned response to experience. As a consequence the return to primitivism has been misinterpreted, and through that misinterpretation, painters have been thrown into an indefensible position where they must deny the validity of knowledge and set up a pretension to an impossible innocence. They are forced to play dual parts in which the activities of the artist are separated from those of the man exactly as religious "Faith" is separated from the conduct of actual affairs. Withdrawn from the stimulating pricks of reality, their art becomes inevitably a convention and their artistry a mere embroidery laid over these conventions—a sort of costume dance.

Primitives and children know things. Though their knowledge may seem odd to us, it is nevertheless valid. It is limited in range; it may not tally with the conclusions of a wider experience; but psychologically it is just as much knowledge as that of the civilized, verbally and mechanically trained adult.

A child's picture, once he has grown out of the mere explosive play with material, is a picture not of something seen, in

the strict sense, but of something known. He knows a boat or a house or a horse and draws it with total indifference to the facts of visual perspective. His idea is to represent experience rather than to imitate its conditions. Later on, the modern child must take these conditions into account, but his first effort is to get what he immediately knows to hang together within some limited space. The business of making things hang together is his first experience in correlation. He devises various means of making the many seem one. The charm of children's work lies generally in the unexpectedness and emphatic quality of their logical devices. That apparently innate need of the child, the urge for cohesiveness in the materials used to represent a knowledge of things, must be retained for successful plastic expression. The important thing in the education of children lies in developing this urge and in providing techniques of spatial relationships which can be expanded as knowledge itself widens and as the critical faculty (as applied to the representation of knowledge) grows more acute. He will otherwise become, as most modern children of artistic leanings do become, a slave to the representation of appearance and spend the rest of his days trying to disguise the fact with technical oddities of one sort or another.

The difference between the development of the modern child and the primitive lies in the conditioning environment. The modern child grows up with things which induce conclusions and actions of a complex nature. His notions of logic are profoundly affected, and rightly, not only by his direct knowledge of things but also by what they imply. His inferences are derived from his experience of what things do. An airplane is something capable of being known directly, like a stone or a chair, but the nature of that kind of knowledge is immensely affected by knowledge of potential performance. Thus a mass of derivative knowledge enters into the problem of representation which the modern person cannot escape. The primitive, having had no complex instruments to increase the accuracy of his conclusions about directly experienced things, goes about correlating them without too much of this derived baggage.

As a natural result of this, his representations are more readily fitted to logical relationships, and he finds it easy to make an aesthetically satisfying story of the world because there is not so much contradictory material to be included.

The painter's message has nothing to do with derivative knowledge of a scientific nature, with that sort of knowledge which deals with the causal relations of things. What the painter cannot know by direct contact is not his material. These direct contacts have references, implications, extending beyond their immediate existence, but it is to immediate existence that the painter goes for the stuff with which his processes actually deal. He selects from what he knows of things, their significant aspects. These selections, transcribed in line, color, and mass, are his material. It is with water, the glittering, smooth or broken plane, that he deals, not with H_2O. But at the same time he cannot avoid the implications of material, and it is the complexity of these implications which establishes the difference between the modern and the primitive artist and makes the aesthetic organization of actual modern experience so involved an affair.

Art practice depends upon two kinds of knowledge. One kind is knowledge of the use of correlating instruments, such as symmetry and rhythm which is derived from a study of historical practice. The other knowledge is the result of attention to the things of direct experience. What a painting has "to say" is wholly dependent on the latter. Its symbolical reference, its meaning, is bound thereto. Its form, its logic, which correlates what is represented, is the result of instrumental knowledge.

But these two sorts of knowledge affect one another.

In the process of correlating things directly known, needs arise which cannot be met with logical devices of the past. The devices are then modified, more or less unconsciously. Also, the direct knowledge is inevitably subjected to some distortion as it becomes part of a logical sequence. Experience is not of a logical nature—all integration involves distortion of some sort.

Art is then a constant play of meaning against form in which the purity of both is sacrificed to unity. But as art, unlike philos-

ophy, makes no pretensions to the establishment of "truth" in and by its logic, but is frankly emotional in setting up its sequences, its compromises cannot be regarded as evidence of weakness. As a matter of fact, the very strength of art lies in the middle ground where doing is balanced with meaning, logic with experience. A successful work is a measure of both. The various logical devices of painting—the division of things into planes, the counterpoint of line and plane, the playing of color against color, light against dark, projection against recession, et cetera—are instrumental factors set to the service of unifying experienced things.

Devices of structure are a heritage of successful practice, drawn from a long train of trial and error. Their logic is the logic of carpentry which sets this against that in the interest of cohesion. Such a logic is less dangerous than verbal logic, since it is clearly a plain means of simply getting things together. It is nevertheless dangerous for the artist, because it may so readily lead to a habitual unreflective sort of practice for its own sake. Once a way is found of getting disparate factors unified, of making them hang together in a picture, it is natural to cling to that way, especially if accomplishment has a professional aspect. One is likely to shut the door on further disparities, to make art an activity separate from unfolding experience.

In view of the nature of this difficulty, it is very easy for the correlating process to assume so vast an importance that its mere function as an integrating tool is lost sight of. Thus logic becomes an end in itself, and the device all important.

The whole modern notion of "plastic purity" is born of the confusion of the device with its end. The loss of the tradition of logical practice during the period when the novelty of the various tricks of photographic rendition held all the interest of painters has centered a tremendous attention on its revival, and much of our modern art has been, therefore, a sort of experimentation with tools. Rationalization has provided such experimentation with meaning.

Back of the whole modern business, as indicated above, was

the dissatisfaction with a mere arrangement of appearances and the need of knowing and saying something that was the result of human rather than mechanical response. It came to be recognized that the artist as camera was not very satisfactory, that in fact he was not even a good camera.

But the return to traditional practice, as in the case of Delacroix, seemed to call for purely romantic views and a disregard of real experience. This was obviously not a line of true development. New kinds of knowledge of things could not be made to square with a practice directed to correlating knowledge born in a period of flowing draperies and unquestioned, or but moderately questioned, beliefs about the real meaning of things. This problem of finding a logical representation of new experience, new knowledge, is still the artist's central problem. Half of his life is spent learning how. What a contrast with Masaccio and Raphael!

In the face of this difficulty the modern has had to make excuses for his existence.

Unable to make experience fit with logic, unable to relate his practice to his environment, finding himself at odds with society, which naturally is not interested in any practice apart from meaning, he has made a little world of his own and with the help of his literary friends has invented special psychological faculties to provide it with a semblance of reality. In this world he has set up the notion of "purity" as a criterion of aesthetic value, meaning thereby that the elements of artistic practice are sufficient unto themselves.

In life, the claim to purity is practically a declaration of impotence. It is a compensatory value, born and reared in some kind of frustration. Set up as an ideal to be maintained, it is an indication of defeat. It tells plainly that the world of experience cannot be made to coincide with one's ego—that one's notions of fitness, of logical sequence, are unable to stand in the flow of fact; that one's integrative powers are ineffective in the actual world.

As the need for logic, for cohesiveness, for getting meaningful sequences in the facts of life, seems to be more persistent than

any other psychological factor, the brutal assertiveness of direct knowledge is avoided by the "pure."

This mural, "The Arts of Life in America," is certainly not a pure work. Avoiding the suggestion of double meaning here, it may readily be seen that no plastic device is used for itself. Practically every form is bound up with implications which take the attention away from purely plastic values. This is deliberate. On the other hand, the form is not directed to specific meaning in a literary sense. The work is not a vehicle for doctrine. It is not a string of verbal ideas transferred to plastic material. As the implications of things in life vary with individuals, so will the implications of the things represented in this work vary. In addition there will be, and quite properly, individual interpretations put upon the relations set up between the things represented. Such and such a contiguity will seem true to one, false to another. Why I placed one unit here and another there is just as frequently determined by my conception of effective placement as by its "truth" to life. The "truth" to life in this work is "truth" seen through and modified by the demands of logical sequence. And yet, at the risk of verbal contradiction, I must say that the sense of "truth" to life behind this work is what seems most important to me. The whole form is in its actuality determined by meanings arising directly from experience. The things represented were known in real life and found significant enough to call for representation long before the complete form of the mural was considered. The final form here shown is then an attempt to integrate units each of which has in itself its own separate value as a thing, as a true thing, with a meaning of its own.

The conception of perfect sequence is constantly assaulted by the recalcitrance of these units. They can be modified only just so much without losing their representational values. As I try at all times to retain the full representative value of these units, it is inevitable that the sequences of the whole mural be subjected to strains more or less violent. In the interest of representational inclusiveness, the flow of a line is frequently broken,

twisted, and sent back on itself. As a consequence of this, some other line must needs be treated violently as an offset, or counter. From the architect's point of view, all this is, of course, shameful. The cool beauty of a wall comes down in ruins. For the architect, architecture is a frame for life, and, theoretically at least, what is included in a space should harmonize with those life activities for which the space is designed. But the notion of harmony, the directing influence behind decisions determining what goes with what, is highly conditioned by the nature of one's interests.

While architecture may be a frame for life, it also sets up spaces which may rightly be regarded as frames for the expression of life. The question of abstract harmony, itself a little obscure, then gets involved with one of significance; and different individuals will, following the dictates of their interests, set up radically different views.

From the point of view of architectural theory, painting should set about enhancing the beauty of architectural form and should be subjected thereto. The painter, as Frank Lloyd Wright says, "should work under the baton of the architect." That is, he should let the architect determine what relations be set up between his lines, colors, and masses, in order that these make no interference with the effect of architectural structure. This means that significance should be sacrificed to form—that is what it means in the language of theory—actually it means that significance be subordinated to a convention, for only that which has no challenging qualities of its own can exist without radically affecting its surroundings.

As the fetish of purity must inevitably fall when life enters, so the purity of architectural form cannot be maintained when painting enters, unless that painting is so pallid, so much a convention, that it is unnoticeable. There is plenty of painting, of course, sufficiently conventional to have no marked effect on its surroundings; but the architect, though he uses it frequently enough, certainly holds it in contempt. The call for meaning, for

significance, is strong in all men; and even the architect must tire
of empty gesture and sickly archaic affectation.

Painting finds its meaning in life, and life fits into no resur-
rected convention. Painting, inclusive of meanings which are the
result of real life experience, must build logical structures of its
own. Such structures, in and through the meanings they en-
compass, set up unprecedented properties in the lines, masses,
colors, cubes, cones, or cylinders to which they may be reduced;
and these must affect the alignment of similar factors in archi-
tectural form. Painting expresses or represents; but the stuff
through which it does this is finally reducible to a play of geo-
metric factors. As architecture is apprehended aesthetically
through the play of similar factors, there is bound to be reciprocal
action between the two arts when they are joined. Neither can
maintain wholly the purity of its values. Function in architecture
determines the alignment of cube, cone, cylinder, mass, line, and
plane. Structure is at the service of purpose, of meaning. This is
also true of painting, whose most important office is its social
function, the expression of life. The expression of life, tied as it
is to direct experience, constantly brings new units to painting,
because life is always changing. These units, logically adjusted to
one another, set up their own dynamic geometry, which is not the
geometry of architectural form, because it has a different origin
and function. Architecture is built *around* life activity; painting
is built *on* the expression of that activity.

Line, mass, and color—the materials of painting—function
instrumentally in the interests of unity—geometric unity—but
that function is itself profoundly affected by the nature of what
is to be unified if the final form is to have other than a superficial
value—if it is to have meaning.

Architectural logic, the architect's conception of formal fit-
ness, must, like the logic of painting, submit to modification
under the pressure of values which are not inherently its own.

The room, on the walls of which this mural is painted, was
certainly no architect's dream, but it presents, just the same, a
fair example of what painting, which aims to be inclusive of real

meaning, may do to architectural structure—what to some extent it must always do.

Whether the result is harmonious, whether it bears any relation to architectural function, may set some discussion going, but it is likely to become at last a purely theoretical question which will suffer the fate of all theoretical queries in the face of a "fait accompli."

LETTER TO MATTHEW BAIGELL

[November 22, 1967]

I did not at any time think of Turner's thesis as affording pictorial material. It would be impossible to illustrate "The Significance of the Frontier in American History" or "The West and American Ideals." Turner's "Frontierism" lent support, however, to my own more paintable conceptions of the development of our American culture—development through "action of the people" as they moved west with the advancing frontier. This *action* I took to be more generative than *ideas* as our American culture took form. It was certainly more paintable. My views did not deny, as some have said, the role of "intellectualist" ideas on that development—Thomas Jefferson and John Locke, for instance—but saw these as being conditioned and sometimes radically transformed by situations which grew out of actions on the land by the nonintellectual westward-moving plains people—for me, the paintable people.

The better part of our history, cultural history, certainly was the outcome of rural pressures on the centers of cultivation and policy-making. This lasted until the turn of the century and beyond (note effects of rural members in state legislatures). Of course this is no more so. It is just the reverse that now holds. The urban centers now provide the pressures. But our basic cul-

tural ideas, our beliefs as to what constitutes the "American character," our mythologies, had their origins in the earlier conditions. It was these I tried to represent.

THE 1930's

During the 1930's Benton was at the top of his form, both visually and verbally. Certainly one of the most popular as well as important painters at that time, he helped bring to wide public attention American-scene painting through his mural and easel works. In his reconstructions of American life of the past and the present, he provided artists with many thematic and stylistic cues. Although he never completed any projects for the governmental programs, echoes of his concern for local histories and his interest in the lives of ordinary people appeared all over the country, on the walls of public buildings and in the classrooms run on federal funds.

Throughout the decade he continually refined the essential motivating forces of his art—that it must grow from local experiences and that the resulting paintings would reveal a uniquely American style based on these experiences. In an age of national self-concern in other art media as well as in areas

of public activity, he felt obliged to do no less. The term "provincial" for him did not suggest a parochial art from the provinces, but rather an art that adhered to precepts established by others. He exulted in the thought, therefore, that a genuine American art would come from the American provinces, and he found the Midwest to be the likely place for the springing of an original art. It is probably not a mere coincidence that Benton's finest mural cycle and Regionalism's most representative paintings were his panels in the State House at Jefferson City, Missouri, 1936. These works, based on local lore and legend, are among his most completely realized designs and cannot be mistaken for paintings coming from any place else in the world.

Benton's art was largely apolitical, although he never renounced his social idealism. For him, art was an instrument of easy communication between people, one which reflected shared common experiences with his public, which, as Benton pointed out, was not necessarily the art-consuming cosmopolitan public of New York. As his fellow Regionalist Grant Wood once suggested, Benton painted that society in which culture was a way of living rather than a set of acquired habits.

In a polemical decade artists engaged in more controversies and disputes than perhaps at any other time in American history. Their verbal violence was aimed not at their eternally uncomprehending audience, for now many felt that they were painting for particular audiences, but at each other. Regionalists like Benton attacked Social Realists and followers of Parisian modes with equal relish, and they, in turn, did the same. Museum directors were attacked, and picketed, with vehemence by all. The various groups patrolled a reasonably well defined area of artistic territory and intention. Benton's position in regard to the New York–based Social Realists is recorded in an article, a speech, and in a set of answers to questions proposed to him by artists associated with Art Front, a left-wing journal of the time. In stating his position, he helps to make clear some of the distinctions between Regionalism and Social Realism. It should be remembered that Benton did not argue necessarily from a right-wing nationalist point of view. Both he and Thomas Craven recognized the fact that Communism allowed art a social function, that it gave to art a significance in human affairs. Benton, in fact, once indicated that the Communist influence on art was one of the greatest steps forward in the history of art since the time of the Renaissance, when it had become, he believed, an accessory to vanity. What Benton and Craven did find objectionable was the saddling of art to specific political beliefs extrinsic to local needs, histories, and environments. Such an art, to which he felt the Social Realists had fallen

prey, was no better than Parisian modernism. Both ignored life experiences. His book review–essay on Alfred Stieglitz makes this point amply clear.

By the middle of the decade, Benton evidently had had enough of urban living. New York had been his home since 1912 except for his stint as a draftsman in Norfolk. (He has summered on Martha's Vineyard since 1920.) Accepting the directorship of the Kansas City Art Institute after a tour of the Midwest, he returned to his spiritual homeland where he still lives. That he had few illusions about public response to his work and his

personality is borne out by the fact that in the accompanying *New York Sun* interview he said that he expected to find narrow-mindedness in the Midwest. In 1941, as he indicates in his article on museums, he was fired from his position as director because of remarks he had made about museum personnel.

This chapter begins with short statements by the artist which, although written at different times, capture the urgency of tone many artists sought during that painful decade. Benton's words state briefly and succinctly his overarching aims and ambitions.

STATEMENT IN *EXPERIENCING AMERICAN PICTURES*

[Ralph M. Pearson, *Experiencing American Pictures,*
(New York: Harper and Brothers, 1943), p. 140]

I love America. . . . I love America so well that all its
crudities and gross stupidities are no more to me than the little
imperfections which give character and individuality to personal
beauty. A windmill, a junk heap, and a Rotarian in their Amer-
ican setting have more meaning to me than Notre Dame, the
Parthenon, or the heroes of the ages. I understand them. I get
them emotionally. . . . The stuff of this America which I know
directly and immediately is to me more important actually and
substantially than all the art of the past.

STATEMENT IN *NEW ART IN AMERICA*

[John I. H. Baur (ed.), *New Art in America* (Greenwich, Connecticut:
New York Graphic Society Ltd., 1951), p. 131]

I've had many aims. Some are aesthetic, formative, like
those involved in the three-dimensional composition I practice
where relations between things are set up on advancing and re-
ceding planes of an imaginary deep space. Some are procedural,
directed to brilliancy, impact, and permanence in the use of
colors, mediums, grounds, and so forth. But my chief aims have
been social, more publicly directed. I believe I have wanted,
more than anything else, to make pictures, the imagery of which
would carry unmistakably American meanings for Americans and
for as many of them as possible.

ART AND SOCIAL STRUGGLE: REPLY TO RIVERA

[*The University Review* (University of Kansas City), II (Winter, 1935), 71–78. Rivera's article appeared in the same issue of the magazine.]

For one who accepts the Marxist view of history where violent revolution is an inevitable factor in the pattern of progress, the conception of art as revolutionary protest is almost inevitable. For a true believer, art could not be considered vital unless it fitted categorically within the scheme of social progress as envisioned and proclaimed by Marx.

In spite of the fact that industrial development has not increased the numbers of the proletariat—the essential revolutionary element in the Marxist scheme—in any relative scale, but has tended, particularly in the industrial countries, to increase the so-called middle class—a class of skills and small-ownership stakes —Marxists still adhere to the master's conception of the major position of the proletariat in the struggle to put an end to the crude exploitation of human energies for profit. This middle class which, in spite of the efforts of Marxists to classify it, is neither bourgeois nor proletarian, occupies today the strategic position in the world. The lever of mass power is in its hands. The people who by their numbers constitute this mass power are tied by habit as well as by immediate need to the productive mechanisms of capitalism. They will put their weight, should by agitation a class war really materialize, on the side of those who promise to hold for them or regain for them their right to own. This middle class is without class status in any true sense. Its members run with rapid shifts up and down the field of ownership. Their positions are precarious, but their ownership stakes, big or little, real or imagined, are tremendously precious.

If these precious stakes come by indoctrination to be associated with class allegiances and the necessity arises of making a choice of allegiance in a struggle for power between classes, there is no doubt about the choice of the great middle class.

To my mind it is extremely unfortunate that the progressive

democratic elements of Communism, those which would break down class barriers, remove the incubus of monetary profit from human institutions, and spread the share of the abundance that is potentially in the world, should have become tied to the conviction that class war and class dictatorship is an inevitable condition of progress. This conviction, so rigidly held that practical compromises were impossible, must certainly receive a large part of the blame for what has happened in Europe since the war.

In spite of all the dialectical rationalizations, on the part of Marxist Communists, about the course of events in contemporary Europe, it is plain that Fascism is to a large degree the outcome of the Marxist theory of class struggle which left no choice in the political arena except as between two class dictatorships. Instead of a series of democratic compromises in which some (at least temporary) solution of the economic dilemmas of the Fascist countries might have been found, party passion, rigid and uncompromising, flamed into a religious war between political sects. Passionate ideals, particularly those of the left, where it was all or nothing, made it impossible for men to act reasonably. A psychological atmosphere was created where belief patterns grouped around economic issues became more important than the issues themselves. From the look of things now, they promise to remain more important until they succeed in drowning the whole of Europe in blood.

What passionate idealism can do in extending violence over long periods is represented by the Catholic-Protestant struggle following the Reformation, where patterns of faith aggravated the struggle of the trading classes for increased rights of ownership. Beliefs, purely theoretical in their nature, were confused with economic issues, and men fought, not for what they needed, but for what they believed was true. Marxist materialism explains this period, as it does all others, by regarding human belief as a function of the struggle for economic power. It says that beliefs are tools manufactured by economic groups to further their ends. There is no doubt but that men fasten themselves to and propa-

gandize beliefs furthering their material interests, but to accord them such far-reaching intelligence as is implied in the Marxist view stretches credibility too far. Our contemporary experience with economic groups leads us to believe that they cannot see beyond their noses. If, however, the Marxist view of the origin of idealistic beliefs in cunning self-interest were wholly acceptable, we still face the fact that man is so constituted that once a belief gets into his head, it tends to change from a belief to a fact. It becomes an unquestionable, unimpeachable reality—the master, not the tool, of his actions. Ideas which may have been effective tools more or less consciously used in some particular economic set-up have a way of dominating their users, who finally fight for them and die for them simply because they believe. Human inertia in respect to belief is incalculable. Ideas cling in habit when all their real significance in the world is past.

A perfect example of this persistence of belief is afforded by the wide-spread acceptance of the doctrine of laissez faire among American business men. While they are actually and through their own efforts increasing the dominance of business and financial collectives which are making the free competition at the heart of their beloved doctrine an impossibility, they still fervently acclaim it and regard it as the cornerstone of the American system.

An equally perfect example is afforded by the stupid way in which our Communists cling to the theory of the class war as an essential ingredient of social progress. The industrial proletariat of Marx's day, let me say it again, has not developed as predicted. In industrial civilizations so many proletarians have been absorbed by the rising lower middle classes that the mass strength of the proletarian class, as such, has been liquidated. This situation puts the Marxist class war, *insofar as its humane outcome is to be considered,* in a highly questionable position. Yet all good Communists continue to believe in it.

In a country like the United States should it be possible by propaganda to create enough faith in the Marxist conception of

the heroic role of the proletarian to set up a forceful revolutionary body with action-compelling belief in its class destiny, should this be possible, then the result would be some form of Fascism. The reason for this lies in the impossibility of a proletarian class, in the intricate ramifications of ownership in our industrial societies, to achieve the mass strength which Marx predicted for it. Mass strength in the event of a class struggle would be on the side of the lower middle class, which at the moment of crisis would side not with those who would dispossess it, for whatever ideal purposes, but with those who would make promises, however vague, to improve its power to possess. This is realism. Anyone but a convinced Marxist can see it.

The function of the class war, as things have actually developed in the industrial countries, is to put all power in the hands of the most reactionary elements in society. Thus a doctrine theoretically directed toward freeing man becomes an instrument which enslaves him. Subservience to the rigidities of Marxist doctrine has made the left-wing idealist, with his dream of a classless society, little more than a symbolical figure where the actual powers of the world are concerned. Outside of Russia he is only an empty voice. In the end, with the consolidation of Russian powers in the hands of a single political group, he may be no more even there.

What has all this to do with Art? It has a good deal to do, for artists under the drive of propaganda are succumbing in large numbers to the same doctrine which in the political field has lost its power to function progressively through its rigid adherence to predetermined courses.

Artists, who as a rule think little about anything but their craft, have been easy prey for left-wing dialecticians of the Marxist stamp. This is easily understood. Your true artist is generally a man who, for all his faults of temperament, is impregnated with a deep sense of the value of life, of the beauty of the basic human emotions, and of the sadness of the drama of human striving. He sees plainly, today more than ever, that the world is dominated

by artificial structures which are detrimental to the full flowering of life. He sees that human beings are warped and thwarted by the institutions they have built. He sees that a great number of the people who rule these institutions are little better than swilling pigs, fighting over the troughs of privilege. The spectacle is not pretty. While he may be drawn toward it, because it is life, in his heart he hates it.

When the artist is confronted with Marxism, usually first with the ringing cry of the *Manifesto*, he is given a picture, not only of a better world, but of a perfectly logical way in which mankind may achieve it. Better than that, he is told that the way outlined in the document is an inevitable way; that while it may be temporarily thwarted, it will eventually take its course. As the artist rarely has any vested interests to defend which would tend to cool him off before the thought of a communally owned world where human relationships, relieved of the burden of economic strife, might presumably be more decent, he is easily persuaded to accept the Marxist view of social change. Its ends are ideal; and in his simple humanity he says to himself, "This world is cock-eyed and mean and dirty. Let's join the Communists who know how to change it to a better world."

Were a simple gesture of faith all that were demanded of him as a Marxist Communist, the question of the position of the artist in the social struggle would never come up as a vital question. The artist would do, granted that he was not a venal practitioner but a sincere and intelligent person, what the artist has always done, when free from compulsion—reflect and picture the life he lived within the conditions, decadent or progressive, of his craft. But there is a string tied to the artist's acceptance of Communism. Art must be revolutionary. It must be a function of the proletarian struggle. So far as I know this was not explicitly predicated by Marx, but it may be reasonably regarded as implicit in the Marxian assumption that human activity is a function of some aspect of economic struggle. In any case, it is at present an essential part of Marxist policy as applied to Art.

Whatever the "correct" interpretation of Marx on aesthetics, it is doubtful if such a theoretical question would have ever left the obscurities of dialectic philosophy had it not been for the failure of the Marxist proletariat to rise as predicted. This failure to rise, which, as indicated above, was on account of the spread of unforeseen middle-class ownerships, has made it necessary for the Communist party, which clings rigidly to the doctrinal necessity of a militant proletariat, to take on the task of making one through education. Where the progression of events has failed to provide a militant proletariat in reality, convinced and faithful Marxists have set out to make up the deficiency by innoculating social groups, from lower-middle-class workmen to college boys. Apparently they expect, through proselytizing, to attain what they have failed to get through the flow of event. A revolutionary weapon is to be manufactured.

Marxists in a country like the United States are not directors of men in actual economic struggles to any significant degree. They are evangelists of a faith, of a doctrine. They are more like Holy Rollers than politicians.

The effort to make reality fit with the tenets of doctrinal faith occasions some extreme distortions in the field of economics, politics, and history. The same is true of the effort to fit the role of the artist to the faith. Among the most violent distortions of evangelizing Marxism is that which treats the history of art as a history of revolutionary political propaganda. This extreme view is a distortion even of the doctrine which it represents, for Marx's conception of the function of art never gave it this self-conscious, didactic aspect. Nevertheless, the view has found a large place in the hearts of those infantile leftists, the "fellow travelers," artists and intellectuals whose vanity impels them to assert their function and look for a front seat on the proletarian bandwagon. It is accepted by party officials, though I imagine sometimes with a sly smirk, as part of their educational program. As the view cannot be sustained except by throwing most of the world's art out of the picture as "untrue art," it is interesting only for the effects it may have on the artists of today.

Generally speaking, it would be much more in accord with Marx to say that art has never been revolutionary, for, except in a few rare instances, it has simply accepted and reflected the phenomena of life as given. It has represented the conditions set up by economic powers. Its function has not been to change these powers but to reveal their effects.

There is one historical period, however, which comes to mind, the early Christian period, where this revealing function of art was subordinated in an unmistakable way to propaganda, where it became strictly an instrument. This period has interesting parallels with our own, particularly if one agrees that social institutions, as we today have known them, are running to decadence.

Christianity began its rise in the Roman empire when the institutions of the empire were failing. The whole culture of the classic world, grooved in habit, enslaved by precedent, was engaged in imitating itself. Art at the time was mainly a decadent continuation of Periclean Greek practice. It was an abstraction. It did not refer its procedures to life but to art.

In this era of enfeebled institutions and practices, Christianity developed. It was concentrated on a specifically defined end, salvation in the face of an imminent break-up of the world.

From the simple hopeful faiths of the primitive groups it developed a series of patterned beliefs which, as the Church rose to power, were consolidated into two main bodies of doctrine. These bodies of doctrine assumed more and more authoritative forms as time went on, and eventually we have the spectacle both in the Eastern and Western worlds—Rome and Constantinople —of efforts by doctrinal authoritarians to enclose the whole of life within rigid schemes of belief and action. A tremendous amount of blood was spilled to force men to look at life, act within it, and be saved from its effects in certain doctrinally correct ways.

During this period fanatical devotees, narrowly sectarian, looked with abhorrence on the pagan art of the old Greek mas-

ters. Because that art did not fit symbolically with the tenets of Christian doctrine, the greater part of it was mutilated or destroyed. Art had to be "correctly orientated" or it was not Art.

But because art is practice before it is anything else, even before it is a reflection of life, Christian artists in learning to practice had to refer to precedent. The only acceptable precedent to the fathers of doctrine were those forms which the early primitive churches had borrowed from Greek art in its decadence. These forms renamed—a decadent representation of Orpheus for instance becomes Christ the Shepherd—were the only correct forms. They had become standardized symbols, "idealogically correct." The artist could not refer his art to life or to the procedures of classic art unless his references produced goods with the *right* content. In the end he quit referring to life at all. It was too dangerous. He referred only to accepted forms of doctrinally correct art.

We have here a pretty good parallel of the position of the Marxist artist today. Though Marxism has not the compelling power—coercive force—possessed by Christian doctrine, nevertheless, the artist who accepts it is likely also to accept its extreme implications and be just as much a slave as was his Christian brother of the past. He cannot be an artist, according to the faith, unless his art declares unequivocally his adherence to the belief that social progress is in the hands of a rising industrial proletariat. He must fit his forms to this doctrinal necessity or he is not an artist.

The modern artist, like the artist of the Christian period under discussion, is also drawing his procedures from a decadent period. This is true not only of Marxist artists but of most others. Modern art today derives its methods from the post-Cézanne period which was mainly a period of technical experiment in which art referred to art far more than it did to life. It repeated, with various changes of idiom, the art of the near and remote past. It was an eclectic period of imitation rather than creation.

Artists excused the emptiness of their forms by saying they were pure. The whole artistic produce of our immediate yesterday may be regarded as reflecting the economic anarchy centering in the World War. It may be seen as an accompaniment of the crisis of European imperialism just as decadent Greek Art was an accompaniment of the decaying imperialism of the Roman empire. As in the decaying Roman world a revolutionary doctrine with ideal ends came out of the sanctuaries of thought and secret agitation into public life, so today another arises. It also promises salvation, salvation from the evil of brutal, poverty-producing, war-generating institutions. Toward art it takes the same view as its ancient parallel. Art becomes in revolutionary Marxism, as it did in revolutionary Christianity, a vehicle without value except as it carries meanings predetermined in doctrine. It may not search for meanings itself. Its function is a subservient one. It must voice the findings of authority.

But art is primarily simple, habitual practice, closely tied to precedent. It has no means of vitalizing itself except through turning to and reflecting the world of experience, which it cannot do when subservient to doctrine. The particularities of things and situations, *when a genuine effort is made to represent them,* may be depended upon to modify practices, however deeply ingrained. Out of this modification new forms grow and life gets a new expression. Aesthetic forms in painting or sculpture are not changed by beliefs or by the desire to illustrate verbal meanings. They are changed by those aspects of the living world which the artist experiences and which he tries to express.

Christian art, as long as it was tied to doctrine and attempted only to illustrate the meanings of doctrine, remained an art of dry symbols. These symbols were as aesthetically empty as the decadent Greek forms which were their precedent. Christian art was priest-ridden for something like eight hundred years. It spoke

not the voice of art making its discoveries in life but the dead voice of theory, whose tenets it symbolized.

Looking back to the actual effects on humanity of the Christian doctrine as it set about establishing and saving the brotherhood of man, seeing the passion and blood that envelops it, one becomes skeptical of the value of idealistic doctrine, particularly when its ways of reaching ends are predetermined. If doctrinal rigidity was bad for art, it was worse for man.

This brings me to the question that seems most significant for the vitality of art in the United States. Is it to succumb to a doctrine which by prescribing its content, must in the end standardize its findings; or is it to proceed pragmatically, explore the field of experience, and let its content arise from what is there?

If it accepts the instrumental position imposed by doctrine, it becomes simply a vehicle. The struggle of the artist becomes then a struggle with verbal ideas. His search becomes a search for the correct means of presenting such ideas. Man and his environment will have validity, "be real," only as they accord with doctrinal assumptions of what they ought to be. Revolutionary art is no more "free." It can no more, as did Daumier, frankly explore the world. Today its responsibilities have crystallized. Its function has been stated. The protesting artist must protest in accordance with the pattern of doctrine which he accepts as true or find himself constantly assaulted by his doctrinal brothers. The end of all this is a standardized art of symbols, representing not the artist's experiences but his sectarian beliefs, his principles.

If American art elects to follow, on the other hand, the simple call of life, to see its functions as reflective, it must proceed without the help of a directing belief. Against the pattern of Communist belief there is no other defined pattern, of an acceptable nature, which the artist can choose as an alternative. In turning from the comforts of doctrine, the artist must do his own searching for the meaning of life. It is my belief that an original art in the United States can only come from such independent

searching. In the *particular* conditions of our society and environment lie the things which will modify our inherited practices and make our forms alive and original.

These particular conditions cannot be effectively apprehended if the artist's responses are to be conditioned by the logical necessities of doctrine.

The tyranny of principle is the worst of all tyrannies, in art as well as in life. It makes no difference whether principle is a conservative defense of encrusted habit—economic, aesthetic, or what not—or whether it is directed to change: it tends in either case to encourage and develop emotional attitudes which enslave reason and distort judgment to such an extent that the believer cannot see the world except as it corroborates his principle.

ART AND NATIONALISM

[*The Modern Monthly*, VIII (May, 1934), 232–236. This was originally presented as a lecture before the New York section of the John Reed Club, a Communist-sponsored organization.]

The question of nationality and art has no significance without definition of the factors involved.

What is nationality, and what is art?

Nationality may be roughly defined in terms of geographic and racial boundaries. Such boundaries have a historic sanction—they cover the field of recorded event. But they have a practical value more immediately significant. They serve as a base for the political organization of measures directed toward the economic exploitation, expansion, and defense of groups of people within them. Within their limits, powers are consolidated and rationalized. It is in the process of rationalization that a patriotic nationalism is developed. By idealizing and falsifying the order and nature of event, the appearance of destiny is evoked, and that

strange and dangerous fiction—the national will, the will of the people—takes form and gets the emotional adherence which guarantees its protection even to death. The political and military history of the world is a history of the expansion and contraction of fictions of national will erected about subsisting powers. That these powers have an economic base should not blind us to the fact that their strength lies in their rationalization. The slave-owners of the South were supported mainly by those who owned no slaves but who adhered to the dominant ideals, the rationalization, of their section. A political nationalism is orientated in fictions which like those of religion are not investigated. Men are adaptable and flexible in their practical behavior. It is through their ideas and their emotional attachment thereto that they are dangerous, inflammable, and a menace to the world.

Geographic and racial boundaries, though they delimit political nationalism and its idealistic paraphernalia, do not accurately describe nationality as a substantial factor of existence for the simple reason that identical political rationalizations of fact may and do exist under different racial and geographic boundaries.

A definition of nationality which can have a bearing on the cultural question raised today must be more explicit and avoid the fictions of political nationalism.

The political nationality which is a defense of, or a bid for, power has, like other idealisms, some bearing upon art as it has upon other cultural performances. It has in the past tagged and named and provided fields for performance. But it is utterly erroneous to suppose that it can develop art by fiat or suggestion, as it can create material powers.

The nationalism which can have any meaning for today's question exists apart from the theoretic justification of the acts of predatory or defensive powers and can be defined only in the terms of human behavior within localities, and with constant reference to those localities. The notion that there is such a thing as a common humanity must be abandoned at this point of definition. There are humanities, but not a humanity in the world in which we now live. The characters of these humanities are

subject to a triple conditioning. They are formed by inheritance, involving not just race but a conglomerate of racial factors; by environment, which includes the various industrial and agricultural instrumentalities emerging therefrom; and by the pressure of those psychological attitudes which have their origin in the historic development and intermixture of the other two.

The intricate interweaving of the factors of race and environment in the valleys of Tennessee and Ohio from 1770 to the early 1800's built up psychological attitudes which yet distinguish the inhabitants of this locality from those of Virginia or New England. National ideals of a political nature, already consolidated in the East, split on this rock of substance, both in the War of 1812 and the Mexican War. And they split violently in the Civil War, not only there but elsewhere. These psychological attitudes, which are not made by propaganda but grow under the exigencies of situation and event, are important for this discussion and for a comprehension of the substance of nationality which persists beneath the fictions of political maneuver.

They form the folk patterns which determine the direction and nature of everyday action and thought. They are massive and persistent. They determine eventually even the nature of the political nationalism which must finally conform to folk pattern in its overt action or face constant sabotage and eventual revolt.

These attitudes, however, are not static. They are constantly changing, affecting and being affected by the play of instrumental and environmental factors. But they have their historic evolution which, bearing constantly upon them by the overlap of generations, sets the nature of the culture which they occasion and determines the *form* which expression must take in order to be embodied in that culture and assume an effective place in its people's life.

The relation of art to nationality is to be found in its relation to that real culture which grows out of historic modes of mass-reaction and procedure, and which is the persistent reality beneath the play of ideas, political, scientific, or intellectually decorative, which fringe it and which are mainly the property of

the cultivated and protected. The culture of a people and the substance of their nationality are revealed by their actual behavior, by their ways of life; and when literature and art represent that culture, they sublimate it, rather than as does the parvenu who would escape his background and attempt its displacement.

So much for nationality. Now what is art? Art, in spite of all high-flown aesthetics, is a kind of practice. Like the psychologies of our humanities, it is heavily conditioned historically. And it is also, like our humanities, a reality only in the plural. There is no art, but many arts. The nature of art as a universal has never been successfully defined—naturally, because it has no existence.

The arts are, in their essential natures, forms of procedure which are learned mainly from the procedures of the preceding generation. These forms of procedure, like the generations of men, overlap. As in our human generations, habit is a persistent factor in their evolution.

Ways of doing which have proved successful tend to be repeated. (Apart from economic value, that is the easiest way to vindicate artistic pretension.) The psychological habits of a people always under constant pressure never have the opportunity to completely crystallize; but artistic habits, as they are currently practiced apart from all social pressure and in hothouses of cultivation, readily do so. They get set in molds. These molds are recognizable to intellectual scrutiny, and among active-minded artists set up profound dissatisfactions.

It is because of such dissatisfactions that we have had in the last twenty-five years the spectacle of the arts in constant revolt against themselves as arts—not as representations or even as decorations, but as arts.

This might be healthy but for the fiction of universal art value—a compensatory fiction, which though it excuses the existence of social and intellectual misfits by setting up little fields for performance, is nevertheless, in philosophy and life, a fiction. Those of us who have read much aesthetics realize finally that the verbal plays about the subject are undertaken only by philos-

ophers who have nothing to say—also, that they are attended to only by those little professors and critics whose empty minds find their level in the subject.

Artistic energy, confined to hothouses of international aesthetics (separated today from the life of peoples), is thrown into purely illusory channels—it seeks for innovation and change, not in life (to which genuine attention would force them), but in exotic procedures which are taken over arbitrarily and without reference to their original significance. The field of art today is like a costume ball; those who enter must come dressed up.

We have in the France of the last generation, in Paris which is the center of aesthetic cultivation, a perfect example of the mystic cult of art—its currently dominant high priest is characteristically that rehasher of dead procedures—Picasso—the most luxuriant of the hothouse flowers.

I mention Picasso at this moment not only because he is the idol of all the young aesthetes, but because I know of no more complete example of artistic decadence with the exception of Poussin.

Poussin was the father of the French Academy. Picasso has assumed the patriarchal position in our international modern academy. He is the father of all our Max Webers,[1] and is the sanction for a world-wide eclecticism which reaches even into the vitality of our Mexican school, otherwise the healthiest thing in our world today. Poussin set the example, which has persisted to this day, of digging around the ruins of a dead civilization not for instrumentalities which might further the development of procedures specifically related to his time and experience but for forms themselves. Picasso and his kind continue in this tradition.

In defining art as practice, I purposely omitted its corollary. Practice is, as a rule, directed to an end. This end I would simply define as form enclosing and communicating experience, were it not for the fact that the peculiarly individualistic nature of cur-

[1] Max Weber, a major American modernist early in the twentieth century, painted in the various manners of Picasso, as well as Cezanne, until he developed his own style late in the 1930's.

rent art practice and its defensive aesthetic have tied the word experience to every sort of frivolous and idiosyncratic illusion— have made it the excuse for the communication of nothing but personal vagary which can have meaning only by fiat and *pro-tective agreement.* (You admit that I am a great man and I'll do the same for you.)

The current practice of nonrepresentative painting (today practically all painting is that) is directed to the construction of forms; and these forms, shallow as they may be, are undeniably the outcome of a kind of experience—at their best, of scholarly experience. Even the form, then, that is borrowed, taken over hook, line, and sinker from the past, indicates and communicates experience of a certain nature. Flowers *do* grow in hothouses.

But this kind of experience has no significance out of the limited field of practice, and I do not believe there are any in this group who would willfully limit art's meaning and function to itself. That notion survives only with those who still carry lilies.

A definition of a significant art is, then, thrown back on a definition of that kind of experience which can generate it. Experience limited to the field of practice can produce only exercise in practice, and no high sounding names attached to these exercises, or meanings read into them, can change their real nature.

A living art is not made by scholarship (that is possibly why it is not likely to be understood by professors or by the run of artists who are, judging by their jargon, merely poorly educated professors).

A living art, or living arts rather, are generated by the direct life experiences of their makers *within milieus and locales, to the human psychological content of which they are, by conditioning, psychologically attuned.* Their forms are the result of the integration of these experiences, of the effort to order and relate sequentially what they know, not what they are acquainted with, but what they *know.* Through practice these forms are externalized.

Experience then, as it bears on the question of a vital art, is closely tied to locales. As experience of this nature is heavily

conditioned environmentally and psychologically, it has a direct social relationship to the community. Experience of the kind of which we are speaking is within locales literally shared and participated in by others. The lay participant in art practice has a base for judging the meaning and reality of the forms in which it eventuates. The forms of art take on revelatory functions in and through which they may even carry messages which are inherently verbal rather than plastic.

We are now in a position to bring up the question of nationalism as it bears on art. I make the statement that it is inseparable from a great art, certainly from a great representative art.

Nationalism, which is fundamentally localism, produces cultures, behaviors (specifically reactions) which cannot be understood or grasped unless they are emotionally participated in. (This will involve negative as well as affirmative reactions.) A protestant condition is as real as any other provided it has a real base.

Regarded merely as phenomena, behaviors may be picturesque, amusing, or hateful, as the previous conditioning of the observer determines. But comment upon them can have only the sort of significance that is found in the observations of a Mrs. Trollope, made after her visits to our early Western country. Dickens, who also brought his art to our America, could only comment.

It takes a Mark Twain, with direct national experience and a properly attuned psychology, to write a *Huckleberry Finn* and make a work of art which is actually an expression of its locale. An imperfect work of art, but a real one.

What is it that distinguishes the various manifestations of the Christian and Buddhist arts?

The subjects in these manifestations are the same.

What makes the Flemish, the German, the Italian virgins of Christian representative art so different?

The difference is made by the life experiences of the creative artist who made his forms from his intercourse with the local virgins.

Let's put it that way, for it is in just such substantial con-
tacts that living arts find those driving motifs which will not
tolerate either the continuance of *habitual* and perfunctory prac-
tices or the borrowing of exotic ones.

It was not religious propaganda that made Christian art.
Early Christian propaganda frowned upon all art which went
beyond the naked symbols of doctrine. Art practice was a hang-
over of paganism, of a hated idealism, the spirit of which persisted
in spite of *revealed destiny* and the promise of salvation.

The world in the latter days of the Roman Empire while
Christianity was coming to effective power was predicted by the
Christians, and believed, to be coming to its end; and art was one
of the vanities of the inevitably damned which had no place in
the kingdom of heaven immediately due.

It was only when the world refused to end, when the prom-
ised land passed into infinitude, when the rigidities of the doc-
trine which maintained the one and only way of reaching the
promised land broke down in the face of fact that the arts return-
ing to life took on that vitality and inventiveness which still
reverberates. In Byzantium it began, under the local influence of
inherited Greek practice, decadent it is true, but still attuned to
the local psychology; from there the story of the local condition-
ing of form and content goes on till art is taken by the Medici
from its public place and made a plaything for economic and
intellectual aristocracies.

You members of the John Reed Club who have submitted
your artistic efforts to the dominance of doctrine have something
here to think about. You may make good priests in the road you
are going, but unless you are able to subordinate your doctrines
and realize that the actualities of direct experience are of more
value for art than the promised land, you will not make artists.

The ability to submerge yourself in the actual culture, to
emotionally share the play of American life, with or without your
baggage of verbal convictions, is your only hope of producing
anything but stock figures or bare symbols like those of Hugo

Gellert and Louis Lozowick,[2] into whose work nothing enters but convention.

Members of the John Reed Club, you had, a short time ago, a plan for a miners' exhibition. How was this exhibition to be made? I got your letter. You were to supply photographs of so-called factual material, and your artists were to select from those photographs their motifs. Putting it plainly, your artist was to make his communication by hearsay, to organize his plastique on records of appearances. Experience and that fundamental sort of direct knowledge which comes from it, which makes fact a reality and which supplies the integrity of expression based on it, was of no concern to you. You would make forms by pushing appearances of which you had no substantial knowledge into those models which you have taken second-hand from European artists who have borrowed them from cultures which were not a reality for them either. Do you think that the miners will do anything but laugh at such junk?

To get back—art, and this time I'll hold to the singular, is a local phenomenon; to be a living factor it must meet and know directly the conditions of its locality—it must be the mirror held up to life—capable of being emotionally participated in by the locality. It is possible for an artist to be born in one place and take root in another—but that taking root is essential if his work is to function socially. Otherwise it is ineffective comment, or effective only among the verbally enwrapped intelligentsia, for whom life is made up merely of a habitual opening and shutting of their books and mouths.

To conclude—and in answer to some persistent questioning— I have not joined those who have been protesting the indignity put upon Diego Rivera's work in the Rockefeller Center because I do not feel, in view of the seriously decadent condition of our own art, that what happens to a Mexican art is of great importance.[3]

<hr>

[2] Both of these men were leading left-wing artists and illustrators during the 1930's.

[3] Because Rivera refused to remove a portrait of Lenin from a mural he was preparing for the RCA building in the Rockefeller Center complex, he was fired and his mural was destroyed.

I think a more significant protest could be made and raised against all the other junk that is still up there—the rest of the junk that gives the other side of *international style* where stale habit and polite gesture, from Ezra Winter to Manship, Sert, and Brangwyn, takes the place of doctrine.[4]

I respect Rivera as an artist, as a great one, but I have no time to enter into affairs concerning him, because I am intensely interested in the development of an art which is of, and adequately represents, the United States—my own art.

INTERVIEW IN *ART FRONT*

[I (April, 1935), 2]

1.—*Is provincial isolation compatible with modern civilization?*

This involves two further questions: What is provincial isolation? What is modern civilization? The first question is tied up with the meaning of the word "province," which is a division of a state or empire—an area which is dependent. Now dependence is a relative factor, and the degree of dependence of any area would determine its provincialism. If the degree is large, the element of provincialism is large and the status of an area, quite apart from nationalist ties, could be set within the meaning of the word province. (As, an economic province.) This would not do for the United States, to which the reference here seems to be directed. The United States is not dependent on any state or empire, even though it imports goods, mental and material, from states and empires. (Note the plural.) It is true that there are provincial areas within the United States. The

*Ezra White, Paul Manship, Jose Maria Sert, and Frank Brangwyn, artists of academic persuasion, also received mural commissions for the Rockefeller Center complex.

Communist party, for instance, as it is presently constituted, in-habits such an area. This area is not physical but psychological. It is none the less an area—an area of thoughts and beliefs. The provincial character of that area is determined by the degree in which it is dependent upon a body of centrally controlled thought —an empire of ideas and beliefs. The Communist party at present is an isolated mental area in the United States. It is a dependent, a province of certain kinds of thought, and it is set in a region where the sort of social behavior and instrumentation which ac-tually objectifies that thought is checked and frustrated.

Is this kind of provincial isolation compatible with the existence of a kind of civilization where communist behavior is presumably unchecked? The question here seems, when the factual side is considered, to need an affirmative answer. This does not, however, cover the whole of our question which is complicated by the concept "modern civilization."

A civilization, in fact, is a thought and behavior complex. Factually regarded, there are at present a number of modern civilizations which think and behave quite differently though they possess the same tools. The question here deals with some-thing which has no factual existence. It deals with a concept. Though it refers to observable fact (use of like tools, for instance), this concept sets up a unity which is not in observed fact itself but in the verbal techniques that describe it.

Our question, if it is to be realistic or intelligible, now reads, "Are areas of provincial isolation compatible with modern civili-zations?" The word "compatible" involves "beliefs" about rela-tions which are too complex for discussion here, so I am forced to answer this question by saying that areas of provincial isolation do exist and that modern civilizations do exist and that as long as they are able to coexist, there must be congruities present which allow for that coexistence. In view of "what is," my answer to this question is "Yes." May I say, however, that I regard the question as fundamentally nonsensical. It does not deal with observable things but with notions.

2.—*Is your art free of foreign influence?*

This is a straightforward question, free of devious intellec-tualities. The answer is "No."

3.—*What American art influences are manifest in your work?*

This question can only be answered by defining "art influ-ences." Art influences are historically of two kinds. There are instrumental and perceptive influences. (Perception is regarded here as that psychological process which sets up relations between the individual and phenomena external to him. The artist's per-ception is regarded here as it is directed to the world which exists apart from the specific instrumentalities of artistic process—to the "real" world.) The instrumental influences of art are the "ways of doing" that are *known* to the artist. The more that is *known* of the history of art process, the greater the body of influ-ence. The less that is *known*, the more limited the body of in-fluence and the more obvious any particular influence. American practitioners, for the greater part, look like French practitioners, because they know (have learned) only French practice. With a wider knowledge of historic process as a whole, they would have escaped the sort of provincialism which is involved in the imita-tion of French process. This provincialism is analogous to the sort of provincialism touched upon in the first question. It indi-cates dependency. French process was and is influenced by the French practitioner's knowledge of a considerable body of his-torical process which is not French. French process, nevertheless, gives results which are French. Why? Because of the entrance of influences which are not instrumental but perceptual—influ-ences which come not from process but from perceptions of things and relations of things in the French environment. These perceptions have forced modifications in historically known traditional practices. These traditional practices were developed in other than French environments where perception dealt with other than French phenomena. These practices could not, conse-quently, without modification "cover" the "stuff" of perception

in the French environment. It is in this forced modification of process by the "stuff" of perception that forms are developed. Forms, that is, which are not *imitations* of other forms. There is apparently no other way of doing it. Any study of Symbolism, of the "read in" meaning in its connection with art, will show that meanings, when they are transferred from beliefs to forms, do not affect changes in forms. Forms are changed only by the effects on process of perceptions that processes fail to cover. Perceptions are the contradictions to the form thesis when it (the thesis) is taken to a new environment—these contradictions are "resolved" by a new form which "covers" the contradictions involved in perceptions. The new form is in actuality a synthesis. If this seems too material a view of art, remember that it is in harmony with the pragmatic aspects of Marxist thought, to the whole body of which your beliefs are committed.

The answer to this question is in the form of my actual work, where my perceptions of the American environment have influenced my historical knowledge of processes (French and other) and set up a new synthesis which no one can confuse with other syntheses, French, Mexican, or what not.

4.—*Was any art form created without meaning or purpose?*

An art form is a complex of practices. First, it is practice which is learned. Second, it is practice undergoing modification through the pressure of perceptions which the learned practice does not "cover." It is, third, a new "statement of relations" between the elements of practice after these have been modified. This new statement involves a new logic (formal relations) and has generally new associations. This is true whether practice deals with geometrical forms which represent nothing or with geometrical forms which represent something. All art-form elements may be reduced to geometrical or sensational factors. An art form is then, in the last analysis, a material thing. To translate a picture or other form into its geometrical and sensational components is, however, an intellectual feat. It is not necessary for setting up those relations which in practice, for instance, make a

picture. It is not necessary or, in my opinion, advisable to cut away the associative content of the perceptually affected elements of form-making. Where this is done, symbolic meanings are "read in" to the form to make up for the lost content. Art forms are involved with purpose even when they are simply embellishments. When they are representations, they are involved with the meaning of our perceptions—which involve, again, a great body of associated meanings. The answer to the question, with the information I have at present, is "No." This question cannot be answered as if "aesthetic" values were separate from human ways of perceiving and doing.

5.—*What is the social function of a mural?*

This is for society, as it develops, to determine.

6.—*Can art be created without direct personal contact with the subject?*

If I am to understand the word art to denote an original form type and the word "subject" to mean what the form type represents rather than what it symbolizes, the answer is "No."

7.—*What is your political viewpoint?*

I believe in the collective control of essential productive means and resources, but as a pragmatist I believe actual, not theoretical, interests do check and test the field of social change.

8.—*Is the manifestation of social understanding in art detrimental to it?*

"Social understanding" is simply the outcome of a body of beliefs which are more intellectual than directly perceptual. "Proof" for such beliefs is afforded by submitting perceptual stuff to ideas which explain it—to rational conceptions. Rational conceptions impose orders on the flow of experience and remembered experience (history). Conceptions become theses when, for any of a dozen reasons, they are regarded as true. When a thesis is accepted as true, it becomes an object of belief and gets involved

with all the emotional accompaniments of will. Many various kinds of "social understanding," forms of the "will to believe," have, through history, undoubtedly affected artists. Beliefs do affect the relations that are set up between things which are perceived, but it is actual perception of things in their environmental settings which finally determines the nature of a form. Beliefs may themselves be read into any traditional and stereotyped form —they may also accompany or affect highly original ones. Belief, when it becomes dogma, has been historically detrimental to the evolution of artistic practice, because belief, as an intellectual attitude, is satisfied with symbols and resents discoveries in perception which might force modifications in belief structures (as well as form structures). I refer you to the history of Early Christian art—to Navajo sand painting—to any area where form making became crystallized in a style (way of doing) dominated by belief meanings. Particular historical references, however, cannot make us sure that beliefs are always detrimental to the development of form types. Evidence indicates only that they are generally so. I will say then that "social understanding" as a belief form is generally detrimental, though not necessarily so. The "social understanding" of Daumier and Thomas Nast did not keep them from being great artists, any more than Marx's conception of history ("systematic unity of the concrete world process" progressively unrolled, an "ought to be" in a dialectical movement) kept him from making intelligent statements about his perceptions of fact. (Greater part of chapters 12 and 13 of *Capital*.)

9.—*Is there any revolutionary art tradition for the American artist?*

The answer here lies in the history of America, where the "turns" of affairs have a form not be confused with "turns" in other areas, though they may develop structures which are similar in intellectual analysis to structures in other areas. (The case of private-ownership structures in the United States and throughout the world is here to the point.)

Intellectual analysis is a reducing process of thought which takes the individual and characteristic from phenomenal things in order that they may, as abstractions, be logically related in theory. Theory is directed generally to imposing "meaning and purpose" through logical orders on the flow of phenomena.

In the current Communist sense, there is no revolutionary tradition for the American artist. In the sense which I have developed above, which declares a necessary relation between perception (of phenomena) and original form making, there is plenty of revolutionary tradition. It began with the first effects of the frontier upon provincial forms in the East and South and continues to this day in the actual moves of conflicting interest.

The answer is "Yes" if you know your America.

10.—*Do you believe that the future of American art lies in the Middle West?*

Yes. Because the Middle West is, as a whole, the least provincial area in America. It is the least affected, that is, by ideas which are dependent on intellectual dogmas purporting to afford "true" explanations of the flow of phenomena—those rational schemes which arise in and with groups who do not labor with *things* but with verbal abstractions supposedly representing them.

Because in that area the direct perception of *things*, since it is less weighted with intellectual conceptions of meaning, purpose, and rational progression, has a better chance to modify "ways of doing" in an unstereotyped and uncategorical manner. Because, unlike the East, as a whole, it has never had a colonial psychology, that dependent attitude of mind which acts as a check on cultural experiments motivated in the environment.

Because in spite of the crudities and brutalities inseparable from its life and heritage of frontier opportunism, it has provided the substance for every democratic drive in our history and has harbored also the three important collective experiments in the United States. (Rapp, Owen, Amana.) These experiments are important, even if untimely and utopian, because they attempted

in fact the realization of a profound human dream and provided thereby, if nothing else, an illustration of the error of trying to make dreams come true through "the mere holding of idealistic conceptions."

Because of the rapid contemporary growth of interest in artistic construction and expression which is now providing the rising Middle Western student of art with magnificently equipped schools and libraries in which he can find illustrated and exemplified the whole history of aesthetic practice. Here in a large field of choice he will find his instruments, his knowledge of historical "ways of doing" without having them so conditioned by subservient attitudes that he can never use them in reference to his real experience.

Because the Middle West is going to dominate the social changes due in this country and will thereby determine the nature of the phenomena to which the artist must react if he is to make forms which are not imitations of other forms.

And because there is among the young artists of the Middle West as a whole less of that dependent, cowardly, and servile spirit which, as a state of intellectual impotence and neurotic fear, is always submitting itself to the last plausible diagnostician "just to be on the safe side."

AMERICA AND/OR ALFRED STIEGLITZ

[*Common Sense*, IV (January, 1935), 22–25]

Here is a book, 328 pages, 120 pictures, which, as the cover claims, has no parallel in America.*

The book is nominally about Alfred Stieglitz, photographer. Actually it is a sort of reaffirmation of the old biblical dictum

* *America & Alfred Stieglitz: A Collective Portrait* (Garden City, N.Y.: Doubleday, Doran & Co., Inc., 1934).

"and the Word was God." It is extravagant and windy, but it reveals the mental character of a group of intellectuals who keep themselves in the public prints, and it has, therefore, a measure of importance.

For the benefit of readers unaquainted with its subject, let me say that I can testify to Stieglitz's existence in the flesh. I have known him for twenty years. He is a "character": one of those fellows whose intensified habits of self-regard set them apart. He may be seen almost any time around the Fifty-seventh Street district of New York, in his gallery or on the street, where, conspicuously dressed up in a long, flowing cape, he makes his bid for attention. Stieglitz is the kind of man who sits when others stand, and stands when others sit. He is picturesque, consciously and effectively so. He has a mania for self-aggrandizement, and his mouth is never shut.

And yet this Stieglitz is likeable. More than that, as this book plainly indicates, lovable, capable of arousing a genuine devotion. It is true this devotion is aroused among ingrown, touchy people, but it stands just the same.

Before considering the book itself, let me pay my respects to that behind it which is real, to the part that a man is loved by his friends.

The book is edited by Waldo Frank, Lewis Mumford, Dorothy Norman, Paul Rosenfeld, and Harold Rugg. It begins with the statement that is it not a collection of tributes. This is to befuddle the reader, for it is exactly that: a collection of tributes to a man whose influence, once potent in the field of American art, is now dead. Stieglitz had an effective place in the days when the "modern movement" held its illusory promise of achievement through "mood cultivation," when painters believed they could safely abandon representation for what has turned out to be an empty purity. Those days are past: the flow of American art has run toward a socially and environmentally conditioned expression. It has forgotten them.

Though Stieglitz's influence on art has vanished, let me make it clear that he has done things of a substantial nature. His

work outlives his talk. Stieglitz reached a high mark in the development of photography. Though this is not enough to create a prophet, it is no mean attainment. And it might have satisfied his exalted temperament were it not for the entrance into his life of the talking artist, the theorizing painter and sculptor.

I can understand this. I was one of those who frequented 291 Fifth Avenue, when Stieglitz kept open house to the talking artists. I am certain that no place in the world ever produced more idiotic gabble than "291." The contagion of intellectual idiocy there rose to unbelievable heights. It is not strange that Stieglitz found full sanction for reading into his life and work any value he saw fit.

But the talking artist—he is nearly always young—does grow up and attain, if he works, to some measure of common sense. Under this influence, Stieglitz might have returned to the bounds of reason, had it not been for the appearance of a rising group of literary men avid for something to write about. The economic and political situation had not, at this time, become active enough for the attention of belles-lettres, and these young writers swarmed in the sink of self-revelation that Stieglitz provided, like flies in a honey pot. Cleverer with phrases, they soon surpassed the painters in extravagant assumption.

After the collapse of 291 Fifth Avenue, it is to the rising young writers rather than to the painters that we must look for the continuation of Stieglitz's influence. American painting struggled out of the hothouses and returned to the field that produced Nast, Homer, Eakins, and Ryder—to the field of American life. Contrast, for example, the rising power of such men as Wood, Marsh, Curry, and Gropper with Marin, Hartley, and Dove, who were the spearheads of Stieglitz's influence.[1]

There is not space here to go fully into the background of literary men from whom the writers of this book were drawn, but the writers had one thing in common. They recoiled from the

[1] Thomas Nast, Winslow Homer, Thomas Eakins, Albert Pinkham Ryder, Grant Wood, Reginald Marsh, John Steuart Curry, William Gropper, John Marin, Marsden Hartley, Arthur Dove.

rigors of the philosophy of scientific method. They recoiled from the pragmatism and the instrumentalism of John Dewey because they could not bear the implication of these philosophers. *Undisciplined thinking led to a surrender to mere language pattern.*

They were heavy readers, these young men, before they had matured sufficiently to be able to think. The conventional shapes of philosophic writing were burnt into them. The notion that a guiding "ideal" was the first need in the search for wisdom had plenty of historic sanction. The search for such a concept in the "contemplative" and "aesthetic self" became their refuge from the new systems which called for intense concentration on things and situations. They failed to see, as was natural to people in a state of recoil, that theirs was simply a return to certain unfruitful philosophies of the past.

The chapter by Waldo Frank reveals this return plainly. Stieglitz is treated here in one of Frank's characteristic paraphrases as "thesis, antithesis, and synthesis"! The chapter as a whole has no sense, but a careful reading of the following (page 217) will show up the man's affinities as well as those of all the writers in the book.

"I mean 'acceptance' [Frank is referring to acceptance of life] in the mystic sense of knowledge of the self as belonging to the whole, and of knowledge of the whole as belonging to the self. This acceptance does not preclude criticism of parts or even deliberate and mortal hostility of parts; it merely precedes and subsumes them. It is the recognition of a connection with life strictly analogous to anyone's connection with and acceptance of his body. Indeed, the simple mystic is one who 'knows' the cosmos immediately (before analysis or control) as the babe knows its body."

This sort of stuff crops up everywhere and provides the attitude which makes the book possible. It also explains, as its final reference is always the self, how a small group of New York cultists can arrogate to themselves and a simple photographer a position of supreme eminence in American culture, a culture from which by their own commitments they flee.

The chapter from which the above is quoted has its psychological parallel in that by Lewis Mumford, where, in spite of a lot of first-class descriptive detail, one finds the mystic self-reference always on tap. Mr. Mumford's writing is more engaging because more artistically sensitive, but it reveals again the type of mind behind the book—a type becoming so subjective, so steeped in a kind of mystic self-probing that life itself must be specially defined to justify its assumptions.

It is a type of mind which, while it is by no means retiring, as becomes the genuine mystic, is too delicate to mix familiarly with the rough substance of common living, scientific, political, or economic. It is a type of mind which, even as it veers intellectually toward the collectivism of the future, is so fastidiously afraid of contamination that it starts the construction of personal hothouses before there is more than a glimmer of revolutionary action.

These fellows like Frank and Mumford cannot accept either of the "logical" escapes. They can neither retreat into cynicism, nor, with T. S. Eliot, into one of the conventional religious hideaways. They do know that life cannot be denied, that people "live" and have lived even though they suffer and make others suffer for it; that the biological drive is real. As a consequence, there arises within them an odd situation in which, while the substance of life is denied, life itself is "affirmed."

Life, which is the behavior of living peoples, influenced by environment, essentially an interplay of thousands of contradictory factors, becomes for them a conceptual affair, a sort of ideal entity against which the actual historical behavior and the actual contemporary behavior of people are set off as incomplete, inadequate, unreal. Knowledge of life and of reality becomes for them, in their situation, knowledge of their conceptual entity which is, of course, because it has no objective existence, discoverable only in their egos.

It is difficult, because of the lack of system and logic in their expository technique, to place these writers in their proper relation to recognizable fields of thought. But one thinks, when

considering them, both of Neo-Platonic mysticism and classical hedonism.

Such parallels, however, will not stand stretching; for the concern with reality which in the old thinking revolved about "God" or "Being" is for these fellows transferred to what they call "Life," or, as it is always qualified, "Good Life." There is a difference here which emphasizes the oddness of their situation. That difference can best be summed up by contrasting the dictum of Neo-Platonic mysticism "the mind that wishes to know God must itself become God" with the same dictum when it has been changed to "the mind that would know life must itself become life." These are both mystical formulas. But while the first calls for renunciation, because God is plainly not of the living world, the second calls, on its face, for an immediate and abandoned plunge into the actualities of the living world, into the doings which really constitute life.

But here we hit a snag. The true mystical approach calls not only for a plunge but also for suspension of judgment. This last would liquidate thoroughly the assumptions of our writers who have already set themselves up as judges. It would also enforce, life being what it is, some very difficult personal adjustments for them and for those others in this book who share their attitudes.

Can you imagine the writer of the paragraph below standing on a soap box in Union Square, working in a laboratory, sitting with a committee of "ways and means," throwing a baseball straight, or even painting a picture or writing a poem that would get a response from plain people in any walk of life?

The rectangular surface of every one of the prints is divided into two or more rhythmically disposed, intrinsically interesting primary units, which in turn are made up of aggregations of smaller units, some of them fine hair lines, some of them gamuts and rhythms of light. These primary units compose pairs or groups of antitheses, intricately, subtly complementary in point of tone and of shape and balance; for they are predominantly triangular and oval, beak-shaped

and bell-shaped. And these pairs of antitheses define dynamic pyramidal and concave volumes: a prodigy potential in the medium of chiaroscuro for the reason that, when juxtaposed, different qualities of light recede, and fall from, and advance toward, and ascend from the eye at various degrees of speed.

Obviously the writer of this can't take much of a plunge into American life. He would get the "horse laugh" with the promptness of lightning.

This man and his confreres are like boys addicted to bad habits whose imaginative constructions have so defined the qualities of "life" that they are impotent before the fact.

Before the active procession can be joined, our writers *tell* themselves (and others) what it should be.

They are slaves of verbal preconstructions, of vague "ideals" which haven't even the merit of being linguistically clear.

Now as life, even in the foggy mirror of the self, is reflected as a moving series of complexes, indefinable except in the strictest biological sense, the qualified substitute "good life" must be erected to provide an object of definition and allegiance. With the "good life" as a central notion, we are thrown from Neo-Platonism into classical hedonism "where everyone may enjoy but only those with *true insight* may enjoy rightly." Here all the precious refinements of hedonism get their full play—all the offensive pretensions and petty snobberies of the self-elected elite move into the center of the stage. This was the case with classical hedonism when with the Roman patricians it became a "way of life" for dilettantes rather than an exercise in logic for philosophers. And manifestly these writers are "dilettantes" rather than philosophers in the techniques of thinking. There is not one of them who can build up a systematic, logical exposition of anything so that when you have finished reading his stuff you have an idea of what he meant to say.

Take this characteristic bit from William Carlos Williams's chapter on the American background:

One is at liberty to guess what the pure American addition to world culture might have been if it had gone forward singly. But that is merely an academicism. Perhaps Tenochtitlan which Cortez destroyed held the key. That also is beside the point, except that Tenochtitlan with its curious brilliance may still legitimately be kept alive in thought not as something which *could* have been preserved but as something which was actual and was destroyed.

Or this from the combined efforts of the editors in the introduction:

The cultural life in America that Stieglitz's work has shared, nurtured, and projected, . . . is not delimited like a biological body; nor could it be logically controlled beforehand like the summation of an epoch that had already flowered. This life, after all, and Stieglitz himself [as the book reveals], is largely a *potential*.

This is linguistic balderdash: it says nothing. These men have not the reticence necessary to objectify ideas.

They can only weave paradoxical patterns about such trite and obvious facts as that sunshine is pleasant and good for man, or mining unpleasant and unhealthy, or that capitalism produces injustice, or that science fails to produce "objects of allegiance," or that given a collective society, important problems will remain.

The reticence that is necessary to the building of meaningful philosophy is only to be had in the rigid discipline from which these fellows revolted, when, in their youth, they faced the problem of carrying the new philosophy of scientific method from the psychological laboratory into the world of social action.

Their squawks about "problem solving" are simply the squawks of men whose ambitions had led them into fields for which they were unfitted but whose egos were so developed that they could not give up the appellation Thinker for the less pretentious one of Artist (or maybe Historian).

Artistic ability these writers have. They possess unmistakable gifts.

They are sick, but they are talented. The world of art is within their reach (though outside the aura of their friend Stieglitz that world *also* has its problems and calls for discipline). Contrast Rosenfeld's description of Stieglitz's family life with his efforts to analyze Stieglitz's photographs. The first is a clear and winning piece of writing; the second is egregious nonsense. And consider Lewis Mumford on the question of sex as it enters his present chapter and as it enters more extensively his latest book, *Technics and Civilization*.[2] As a philosophical study of the place of sex in society it is junk, but as a work of art it is good. It is the kind of art we have all essayed more than once. It is propaganda art and a reflex of desire. The purpose of such art, in its proper psychological environment, is to prepare some adored one for our antics, to assure her and ourselves also that though we are going to act more or less like goats, we are really "not that way."

In a love letter or a poem this sort of stuff is justifiable and good. But what incredible blindness it takes to suggest, as part of a program for social improvement, the elevation of sentiments which, stripped of verbiage, thousands of young people share and act on every day.

But that is characteristic of this whole group of writers and explains their tie to Alfred Stieglitz, for whom the commonest human actions and feelings become (with his own participation) extraordinary symbolic events.

When Stieglitz aims his camera at a young woman's backside, it is as if he had *discovered* for the first time in history that a young woman's backside *is* attractive. He believes so sincerely in the exalted character of his contacts that he has escaped the necessity, which weighs so heavily on his literary followers, of defining and judging things. The fact that he, Stieglitz, has seen, serves both for definition and judgment. When he takes notice of anything, its place in the "hierarchy of human values" is auto-

2 Published in 1934.

matically determined. Stieglitz reaches the state of mysticism to which his followers aspire.

It is the innocent quality of the man's ego which penetrates his idolators. When he proclaims one of his "discoveries," the magnitude of his faith in its unique character is enough to disarm even a hard-headed person. It has a pathetic quality that pleads for the surrender of your sense so that you may not hurt a fellow human.

Stieglitz is touchy. He cannot be criticized. He never laughs at himself as we common Americans do. He never finds himself funny.

Humor and the role of seer do not go together.

With all the ingenious efforts of the writers of this book to tie Alfred Stieglitz to American life, they have overlooked his most valid claim. But that is their way. They hunt all over Heaven and Earth for what is under their noses.

In the conception of himself as "seer" and "prophet" lies Stieglitz's real tie to the ways of our country. America produces more of these than any land in the world. The place is full of cults led by individuals who have found the measure of all things within themselves. They have not heretofore made the "Literary Guild";[3] and I think it a little unfair that Stieglitz's contemporaries Father Divine and Aimee McPherson, who have such large followings, should be slighted, while he, with such a small band, should be enthroned.

INTERVIEW IN *THE NEW YORK TIMES*

[February 8, 1935, p. 23]

None of us can as yet exactly define this radicalism, nor can I say exactly where it is leading. The young artists of the Middle West, however, have roughly accepted collectivist ideals. . . .

[3] *America & Alfred Stieglitz* was published for the Literary Guild.

[Yet] the radical art of the Middle West will not illustrate orthodox Communist tendencies the psychological attitude of young Middle Western artists is still democratic and they don't act as if they believed in rigid class distinctions. . . .

Orthodox communism regards art as merely a form of propaganda, as merely a vehicle for the expression of communistic doctrine.

These young Middle Western artists, however, as is characteristic of American temperament, are more interested in things than in ideas; and it is just here that I see a battle brewing.

These young artists are interested in their environment, in local scenes, in local history. They are not going to be content to devote themselves to painting communistic theories. I believe that there is going to be a fight for ideas held a priori by the conventional intellectual radicals and by others who in temperament are just as revolutionary but are not dominated by these ideas.

. .

I believe that if there is going to be any art in this country, it is going to come from these regional groups in the Middle West. Both the East and the West Coast are too highly conditioned by borrowed ideas to produce important art soon.

I believe that the communistic idea of art as propaganda leads to the death of art, because it denies experience, and experience is the only thing that changes form. Communistic art sets up symbols, such as the working man and the capitalist, and attempts to produce art by combination of these symbols.

EXCERPT FROM *THOMAS HART BENTON ON HIS WAY BACK TO MISSOURI*

[Article by Ruth Pickering, in *Arts and Decoration*, XLII, (February, 1935), 19–20]

I think Henry McBride was right in 1917, when he said all

my pictures looked like quotations from the old masters.[1] They were. I grew out of French Impressionism and Cubism. I grew out of the period where much interest was devoted to the abstract. All my early study was in procedure. The whole modern movement has been an exploration of the past. We have relearned that design is the important element in painting. But having found that design was an integral part of all art, modern painting still seemed empty. I found my painting sterile, and I parted company with the so-called modern movement—its dry patterns, its unoriginal repitition of historical forms.

To make an original form, it seemed necessary to me to have references beyond art. I had to find something which would be a soil for growth. I found it when I became interested in the background of American life—things, places, and faces. If we are ever going to have a national art, with universal value, we'll have to yield to the pressure of the locality. Otherwise, I'm afraid, there will be only imitation of other forms, of Greek, of Negro sculpture, or a Cézanne landscape.

I never start any more with a preconception of the nature of the form. I start with faces, tree trunks, old shoes. I go on trips through the country. I make thousands of drawings. I see something that interests me, and the formal relations follow.

Only knowledge which is deeply and profoundly a part of one can be communicated through the logical conventions of a form. Such knowledge is found, not on the intellectual fringe of life, or in the illusions of cloistered sensibilities, but in life itself where the drive of a people is felt and shared.

[I paint murals] because I can include more stuff in them. I'm interested in American life. I would like to enclose it all. The mural can carry more aspects within itself than any small painting. It can therefore be more expressive of society, of the panorama. Further, it reaches more people. Strictly from the point of view of art or social value, the mural is not necessarily

[1] Henry McBride was art critic of the *New York Sun* at that time.

more important than easel painting. It's merely a quantitative extension.

INTERVIEW IN *NEW YORK SUN*

[April 12, 1935]

[I am going to Kansas City] because since the depression it [New York] has lost its dynamic quality. On the upswing, New York is grand—when it is building buildings, tearing down buildings, making and spending money, its life is irresistible; and in its drive, it's a grand show. But when it is on a downswing, it gets feeble and querulous and touchy. The place has lost its masculinity.

Even the burlesque shows, which to my mind are the best barometer of the public state of mind, have lost all their uproarious vulgarity.

The zest for real life has gone out of thinking. It is no longer experimental or observant, but has gone scholastic— monkish and medieval. Of course that has come out of Europe. New York has always had a little touch of the colonial spirit because of its large, unassimilated immigrant population, and partly because of the snobbishness of the rich and cultivated who gather here, and who have no way of manifesting their assumed superiorities except by adopting European manners and things which seem smart because they are unfamiliar.

When the town is on the go, the roar and push of its activity sway all this; but when, as now, the trade wheels don't turn or show any promise of turning, New York loses confidence and begins to rationalize and explain itself. And God knows when a town or a person gets to that point, you can count 'em dead. New York is a trading town, and a trading town to keep alive has to trade. It can't depend on the mouthings of economists who act

as if their art was a science; on philosophers who've turned prophets; and on eight or ten thousand amateur sociologists for its vitality. Did I say eight or ten thousand? That don't begin to hit the number. You can't go to any cocktail party or sidle up to any bar without having somebody grab you by the coat lapel and deliver you a body of principles.

Principles . . . that's what the town has come to. It don't act any more, it talks. The place has gone completely verbal, and people are getting the idea that if they can make a sentence that is logical, they have demonstrated a truth.

Even the pretty young ladies who ought to have their attention concentrated in their legs address you with a "Do you or do you not believe?"—and look at you contemptuously when they discover you don't believe anything.

It's a hell of a note when women, who can generally be counted upon to hold on to some human sense and not be fooled by language, begin to go the way of Harvard graduates.

The PWA [Public Works Administration] work in this town has shown that no progress in the socialization of creative and experimental art can be made in New York because of the grip of entrenched conventions on the machinery of action. The two dominant art forces in this town, the National Academy, representing officialdom, and the Communist groups, representing the propagandist view of art, are in the grip of frozen and static belief patterns. They are unable to turn out anything but dead conventions.

The Middle West has no inhibiting cultural patterns wrapped up in a lot of verbal logic, or tied to practice habits that stop action.

I'm leaving New York to see what can be done for art in a fairly clean field less ridden with verbal stupidities. . . . Then, I've been here twenty-one years, and that's too long for any American to stay in one place. Do I think I'm going to escape stupidity in the Middle West? Of course not. Wherever people talk, idiocy thrives.

INTERVIEW IN *NEW YORK WORLD-TELEGRAM*

[Excerpted in *The Art Digest*, XV (April 15, 1941), 6]

Do you want to know what's the matter with the art business in America?. . . It's the third sex and the museums. Even in Missouri we're full of 'em. We've had an immigration out there. And the old ladies who've gotten so old that no man will look at 'em think that these pretty boys will do. Our museums are full of ballet dancers, retired businessmen, and boys from the Fogg Institute at Harvard, where they train museum directors and art artists.

[The typical museum is] run by a pretty boy with delicate wrists and a swing in his gait.

If it were left to me, I wouldn't have any museums. I'd have people buy the paintings and hang 'em in privies or anywhere anybody had time to look at 'em. Nobody looks at 'em in museums. Nobody goes to museums. I'd like to sell mine to saloons, bawdyhouses, Kiwanis and Rotary clubs, and Chambers of Commerce—even women's clubs.

ART vs. *THE MELLON GALLERY*

[*Common Sense*, X (June, 1941), 172–173]

A few weeks ago at a press conference in New York where my latest show had its opening, I made some semiserious remarks about museums and the people that run them. After a couple of highballs I even suggested that a living art might function more effectively in saloons and bawdyhouses than in museums, and that the people who frequent the former might be intellectually better prepared to comprehend and encourage a living art than the kind of colonial-minded aesthetes who inhabit the latter. My

language was "indiscrete," and the newspapers, which are understandably tired of formal banalities, printed it. The newspapers in Kansas City printed it. And the stuffed shirts who raise the cash and govern the destinies of the Kansas City Art Institute, where I have been teaching for the last six years, promptly assembled and fired me. For talking, I lost a job.

Sometimes, to be sure, I talk loudly and decorate the substance of my conversation with linguistic flourishes not generally associated with serious intentions. But I was serious in New York when I let go about this museum business. The country is getting overpopulated with museums. The biggest of them all has just been opened down in Washington.[1] And at the same time, by the law of cause and effect, the country is filling up with museum minds. I see this happening; I look at the young American artist growing up; and I am uneasy. I am afraid that he will again get the idea, like so many of our retired businessmen, that culture is something which must have an exotic label and must come from far away or out of the past to be genuine or worthy of attention.

For the last few years our young and growing artists have been working in the field of American life. They have been referring to actualities of American experience for the ideas out of which they made their aesthetic goods. Their attention to these actualities has been the result of some twenty years of pioneer work by artists who have had the wit to see that a culture is the outcome of a way of life and that an American culture cannot be bought or borrowed. This new reference of our artists to experiences which common Americans share has eventuated in an immense popularization of art and offers the promise for capable artists of an economically sound life. American art has been taken from the garret into the world. The popular magazines give it attention. The public has found something to which it can respond. Even the federal government gives out aesthetic jobs. There is hope that art may again become a living thing, of interest to plain living people, rather than a collection of objects

[1] The National Gallery.

strung up on the cold walls of institutions run for aesthetic dilettantes, amateur philosophers, and generally in memory of dead vanities. There is evidence also at the moment that all this may be lost as it has been lost at other times in this country. That is why I "talked" in New York and got myself ousted from the Kansas City Art Institute.

MUSEUM BOYS

The professors, the critics, the museum boys are ganging up on this new American art. Their lectures and their publications sneer at the art of the "American scene." There is plenty the matter with the American scene as it is expressed in art. All of us who paint today need more in the way of mechanical and organizational techniques than we have. Rembrandt still paints better than we do. But this business of making a living American art that will be as good *in its own way* as Rembrandt's is beyond the understanding of critics and museum boys. They have been conditioned to see art as a collection of objects rather than as a living necessity of the spirit of man. They cannot understand that this drive, in its American aspect, *must* eventuate in objects which will be different in kind from the art of the past which they have learned to know and love. Their sneers at a native art, therefore, are directed at what appears to them a presumptuous denial of the values of art. They cannot understand that what the artist of the American scene denies, in his insistence on environmental stimulus, is merely their own highly conditioned and traditional values. What I am now afraid of, because of the power and prestige of the museums, is that the young and sensitive artist will be caught in his floundering student days and turned away from life and back to imitating the dead or producing attenuations of exotic imports.

We have had artists in this country. Apart from the so-called folk artists, we have had Bingham, Homer, Ryder, Eakins. These men knew instinctively that art to be art and not its imitation must come through factual and poetic experience in life itself.

They were men who had the courage to make their own references to life. What I am afraid of is that the example of that courage will be lost to the American student under the increasing pressure of institutionally supported minds which minimize their importance. The complete fatuity of these minds is demonstrated by their acceptance of the designation "National Museum" for the building in Washington which houses Mr. Mellon's collection of foreign art.

There is nothing national whatever in Mr. Mellon's museum. We are fortunate to have it, to be sure—though the collection is a perfect demonstration of the accuracy of the late Mr. [Thorstein] Veblen's definition of the capitalist love of art as "conspicuous display." The pictures and sculptures there may function particularly as decorations on Mr. Mellon's tombstone, but they remain, just the same, a great heritage of our age-old human struggle to rise above the brute intrigues and passions of economic and political life. Properly regarded, they may provide immense stimulation for art in this country. But they are not our art, and we cannot for a moment regard them as such. They are not our culture, and they cannot add to our culture *except as their technical and organizational qualities have been absorbed in an art based on our own immediate experience in our own living environment.*

The museum attitude toward culture implies that art may be bought and that a collection of objects and a mere cataloguing and memorizing of facts about them constitutes a cultural achievement. This is a scholastic achievement, quite proper when properly seen, quite useful also when properly estimated, but of no direct significance for American culture. It is what I do and what those like me do when we stick our noses into the actualities of American experience and construct our forms from what we find there that is of real significance to American culture. No museum man figures anything whatever in that field. And he will cut no figure there until he admits the inferiority of his present position and declares himself the servant of the living creator rather than the keeper of dead ones. My objection to museum

people is that they are too much like undertakers. They suggest the odor of embalming fluid, and their mouths spout nothing but unctuous paeans to the dead and the far-away. They are a sort of pain in the neck, but they are also dangerous. If they get their fingers into the business of art education, they will kill it.

CREATORS

It is the fact that they are making inroads in the field of art education that causes me to write as I do now. I think everybody knows that I respect sufficiently our aesthetic heritage to recognize that there is a place for museums. As a technician I could not do without them. Let me make it clear that I do not object to museums but the effects of museum minds on our American conceptions of art and culture. The museum and professorial mind is not creative. Outside of certain fields of administration it is purely scholastic. Its judgments are formed not in the so often bitter atmosphere of the creative struggle where there are no catalogued references to determine judgment but in the atmosphere of libraries and collections. The scholastic mind does not make judgments; it learns them, it memorizes them, nearly always with reference to particular kinds of created objects. This learning process apparently has high conditioning voltage for the uncreative mind. Ideas once acquired stick as if glued. Appreciation of objects which differ in quality from those *learned about* becomes almost impossible. Here is where the danger lies in letting professors and museum people get control of art education. Art to be art and not an *imitation of art* is sure to differ in quality from any art that has been learned about. Creative capacities are not only necessary to make it but to appreciate it. The museum and professorial mind is without such capacities or, rather, because some creativeness is found in all human beings, it has been smothered by a mass of catalogued opinions which are regarded as correct and true and not be monkeyed with.

The only people who can teach art or make it of cultural significance are those who create it. Judgments of the creative mind are very unstable, but they are alive and, even when time

may show them to be erroneous, tend to stimulate creativeness. The scholastic mind, tied to accepted judgment, even historically correct ones, cannot function here. Sterility does not produce new life. If we let the museums and universities take over art education and put it in the hands of directors and professors, we will turn our young American artists into copyists. If we don't want our culture to be a series of imitative gestures, we must keep our educational procedures out of the hands of those who don't know or recognize anything else and who are so certain that art is an attribute of the dead that they put thirty-years death clauses in their purchasing programs to keep out the vulgarity of life.

LETTER TO THE EDITOR OF THE ART DIGEST

[XVII (February 15, 1943), 22]

The absorption of the Whitney Museum by the Metropolitan came to me as a shock.[1] I saw the Whitney Museum, whatever minor disagreements I may have had at times with its management, as an important first step toward that decentralization which art like our other activities, cultural as well as economic, must yield to in the future development of our national structure. It was the promising thing in the American art world.

This present move into the aura of aesthetic cartels represented by museums, such as the Metropolitan, with their inescapable monopolistic tendencies, is a backward one. It is a backward step in practical function and a backward step in cultural function.

From the practical side, the Whitney Museum becomes now merely another corridor in a foot-wearying series of corridors

[1] This was mentioned in the February 1, 1943, issue of The Art Digest, p. 3.

where all live aesthetic interests, the existence of which depends upon fresh response, are overwhelmed by the multiplicity of objects displayed. Where there are ten thousand objects of aesthetic interest, there are none. Nobody likes candy in a candy factory.

From the cultural side, the Whitney Museum loses its power to proclaim the separation of art as a living, going affair from art as history. It loses an important cultural function involved in the implications of such a proclamation. It loses the power to speak the basic human truth that participation in and expression of a living culture, however crude that may seem to be, is more important than knowledge about and imitation of a dead culture, however refined that may seem to be.

Its present absorption by an institution whose social function, if admitted at all, lies in representing the parade of history, kills the Whitney Museum's power to say, with any conviction, that contemporary American art is something other than a bid for the sanctions of those whose primary aesthetic interests are directed backwards.

For quite a number of years I have been doubtful about the growth of museums in the U.S. This is not because they have failed to give me my due. They have. I am not making compensatory rationalizations on this matter. I am convinced, and becoming more and more so, that the museums are imposing conceptions of art on the public mind in America which are inimical to the development of our indigenous art. The museums, by the very nature of their Alexandrian character, make history of art seem to stand for art. They make familiarity with aesthetic expressions of the past and of exotic areas seem to stand for aesthetic culture in the present and in the immediate area.

In my own town of Kansas City, and let me say it's a good town to live in, our high respectables take pride in the Rockhill-Nelson Museum. A great deal of money has been spent that that museum might have a collection of historically significant objects. But Kansas City supports no living American art. It keeps a school running adjacent to its museum, but it buys no art to

justify the school's existence. It buys no American expressions for its homes. The well-to-do follow the patterns imposed by the museums and concentrate on collections of antique junk polished up by restorers. Art for Kansas City is a dead thing. It has been dead since George Caleb Bingham died.

Now if this is true of a town which only yesterday was a wild cattletown, strong in the history-making capacities of its citizens, how much more true is it of your Eastern cities who lost their pioneering self-sufficiency long before. Kansas City, through the medium of George Caleb Bingham, used to make its art. Now it imports it. Think about how true that is of our whole country. You know as well as I do that for the better part of our economically influential people, art has become something dug up out of the past and hung up in a museum, or something that looks like this stuff hung up in the home. For this unquestionably decadent attitude toward one of the important activities of the human soul the museums and their backers are responsible. They have put a priggish cultivation in the place of dynamic expression.

The only escape I see for this, apart from the resuscitation of the permanently located saloon (to your horror, mentioned before), is the establishment of small centers, well distributed and devoted exclusively to the contemporary American expression, where the art of the day would be given precedence over the art of history. Constantly pursued, such a policy would eventually set up an atmosphere where economic precedence would be given such art. Without such precedence we will never have a great art. Great art can't be picked up in garrets, "La Vie de Bohême" notwithstanding. Great art has to be paid for. It has always had to be paid for.

I am sorry about the Whitney Museum. It is with great misgiving I contrast its yielding to amalgamation with the past with the attitude of the Russians who sold their dead and exotic art to us, sure in the confidence of a dynamic people that they could make their own art in the present.

History has its place, but it cannot substitute for life.

LETTER TO THE EDITOR OF *LIFE*

[XIV, February 8, 1943, 7]

I want to speak my enthusiasm for your display of Grant Wood's works.[1] It was a fine and timely idea. When the youth of America is out risking death that American may continue to develop her culture in a free world, it is a good thing to show their folks who remain at home that there is an American culture and that there was a man who knew it and who had the force of character and the originality of mind to express a part of it.

Grant Wood, you noted, had enemies. He did. But they were of a breed and kind that any sensible man would want to keep on the other side of the fence. Grant was hated by narrow-witted art professors, by nuts with aesthetic missions, by obliquely turned museum boys, by professional intellectuals, by most of the psychopathic critical fry, by artists whose works were service imitations of those concocted on the prewar boulevards of Paris—in short, by all of the sickly mob that hangs on the skirts of American art. They hated him and continue to hate him, even when he is dead, because his creativeness showed up their sterility. They hated him because his basic depth of character made him secretly aware of their shallowness. They hated him because the straight simplicity of his mind threw a sharp light into the twisted involutions of theirs. And they hated him because he was a successful American artist, which is something intolerable in the hothouse of our art world.

Grant knew what these enemies were like. They annoyed him as mosquitoes are annoying when you are busy and haven't time to keep slapping them off. But they didn't annoy him enough to affect the development of an original American style which will be around speaking for itself when its detractors have rotted back physically into the nothing from which their minds never emerged.

[1] *Life*, XIV (January 18, 1943), 52–58.

THE 1940's and after

The impact of World War II and its aftermath on American artists is a story that has not yet been fully told. Its effects on the younger generation of painters (the Abstract Expressionists) has been documented, but the manner in which Benton's peers responded to the changes wrought by the war is still largely unknown. Painters of realistic persuasion, including Regionalists and Social Realists, found, in the full vigor of their maturity, a range of subject matter and an attitude toward art cut out from under them. In a world caught up in violent conflict and destruction, and one in which America assumed responsibility for the protection and advancement of Western culture, realistic painters had to search for a viable subject matter and style that accorded with changing political and cultural conditions as well as to defend over again the beliefs they still considered basic to the making of art. Perhaps at no other time had the history of American art be-

come so turbulent or so liable to violent change.

Like most artists, Benton's initial response to the outbreak of World War II was to close ranks in defense of the country. He painted scenes of war, as he relates in describing his "Year of Peril" series, calculated to arm the country emotionally for the battles to come. And the war caused him, like most artists, to pause and to reevaluate his art, or at least to think through its essential premises again. A reflective note that was not present before begins to appear in his writings, one which indicates that he is measuring more carefully his beliefs against those of others, that he is exploring more profoundly his own attitudes about art, and that he is assessing his place and role in the history of American art. Few American artists have written so trenchantly concerning the generating impulses governing their art or so poignantly describing what they gave up in service to their art.

Benton continued to paint the American scene after his initial reactions to World War II. Changes in his style, which appeared in the late thirties, indicated a new interest in textural differences, refinement of color combinations, and clearer design patterns. These sug-

gest that the bald presentation of American subject matter no longer sufficed. On occasion he reinterpreted Biblical stories or ancient legends in American terms. In his "Achelous and Hercules" mural (1946) in Harzfeld's, a women's clothing store in Kansas City, he adapted the Greek legend to a Missouri setting. This became a way to tie together American experiences with those of other peoples and other times, to suggest American versions of archetypical events. His subsequent murals, however, explored American themes. These include panels at Lincoln University, Jefferson City, Missouri, 1954-55; the Kansas City River Club, 1956; the Harry S. Truman Library, Independence, Missouri, 1961; and panels for the Power Authority of the State of New York, 1956 and 1961.

In his easel work he explored Far Western themes, extending his range of subject matter over a hitherto neglected (for him) area of the country. The look of the land and a warm feeling for it emerge in all of these works, which, like his writings, are prime documents describing the American scene and his devoted attitude toward it stretching over more than half of the twentieth century.

THE YEAR OF PERIL

[*The University Review* (University of Kansas City), VIII (Spring, 1942),
178–180. *The Year of Peril* series was commissioned by
Abbott Laboratories.]

In this year, 1942, the American people are up against the
greatest evil that has ever come to them.

America is and has always been a country of infinite re-
sources. These have allowed her people to surmount most of
their social difficulties with a minimum of dislocations. Since the
Civil War, America has faced no internal crisis that could not be
adjusted by compromise. In her two major excursions into inter-
national struggle, in the Spanish-American War and in the first
World War, she came out unscathed insofar as her material life
was concerned. There have been no forces, arising in America
itself or in the world outside her borders, which, except in the
memories of a few old, old men, have been ominous enough to
occasion deep national concern. The life of the majority of Amer-
icans now living has been an easy one. They have seen economic
disturbances in which many have faced even hunger and want for
a time, but, confident in their basic national strength, they have
regarded these disturbances as easily remediable. Their confi-
dence has historical justification, for they have seen minor modi-
fications of economic practice take care of impending difficulties
over and over again.

Because of this American background of easy success, the
American people have developed highly optimistic psychologies.
They have even made a cult of optimism, and the very propriety
of considering anything disturbing is questioned by many.

The result of such a state of mind, while it has been pro-
ductive of a sort of convivial brotherhood and has resulted in an
atmosphere in which democratic compromise could make easy
headway, has also had an unfortunate outcome. It has encouraged
many people to become slothful and inclined to dodge problems
which call for hard thinking and consequential decisions. It has

also gotten many people into the habit of pretending that evil does not exist because they do not want to bother with it.

But evil is here. Here now, on our very doorstep, hammering for entrance! It is time for all Americans to come out of their dreams. The war that we are in today cannot be dodged. Its dreadful implications cannot be passed over. This is not a war that compromise can settle. This is not a war that will be pleasantly lost by ceding a few outlying islands. If this war is lost, what we know as America is lost. Democracy is lost. The United States cannot maintain her system of divided powers against the tightly organized military and economic cliques of the "new orders" should these come finally to control all of the rest of the world. She cannot do it in isolation nor by appeasement.

The moment has come when Americans must shake off sloth and face reality and the inescapable logic of events in that reality.

And the moment has come when we must have unity such as we have never known. UNITY. Not merely the emotional unity that flared suddenly after Pearl Harbor, but a unity of all-out, practical, purposeful, and realistic thinking, seeing, and doing.

Without it we perish!

Criticism within this unity is called for, will continue to be called for, in the interests of freedom and efficiency; but let Americans be sure that it is based on consequential fact and that mole hills are not taken for mountains. Let Americans be sure that their criticisms are not merely the outcome of upset precedents, overturned habits, or the expression of minor political grudges. During this time of peril we must give up all of our pet hates and small arguments. We must learn to look out with open eyes on the horror that is actually in the world and see how much greater it is than the small dissatisfactions within ourselves. Let those readers of books and devotees of theory, those intellectuals who still look cynically at our war effort in the name of democracy because we have not yet attained complete democracy, look to occupied Europe and the treatment there of dissatisfied intellectuals. And those leaders of business who are secretly fearful

about our war effort because it brings up the dread specter of socialization, let them look to what happened to those business-men of France who were likewise fearful.

Let those radicals on the one hand, those conservatives on the other, those who think that democratic controls over pro-duction have not gone far enough or have gone too far, let them consider what will happen if they nurse too much their differences in this time. Already, in the face of what actuality presents, these differences are academic. With this war lost, they will be aca-demic forever.

It is true enough that we have not yet solved the problems of democracy. Democracy is not a thing to be taken off any theoretical shelf, to the right or left of any theoretical pantry, and cooked up for serving. Democracy is an evolutionary process, slow, full of compromises and the uncertainties that go with trial and error. The human freedom for which democracy exists could not be maintained by any but such a process.

Let those who are impatient with this fact remember, how-ever, that here in America we have attained a fair measure of democratic political procedure, that we do have a Bill of Rights, and that it is in our own power as a people to experiment until we get the kind of democracy we want. Let them remember that we have free elections; that defeated candidates do not agitate civil wars, and that winning candidates do not kill off their oppo-nents. What we've got may not, from a dozen points of view, be what it should be, but it is ten thousand times better than what the enemy is going to slap down on us if we fail now in open-eyed understanding of what is consequentially actual.

I have made these pictures, as I have at other times spoken, in the interest of realistic seeing and with the hope that I might be of help in pulling some Americans out of their shells of pre-tense and make-believe. The pictures are not technically realistic. They do not represent accurately anything that I have seen with my eyes or that another may see with his. They are realistic just the same. I believe that they are true representations of the moment, even though the symbols used are imaginative.

There are no bathing beauties dressed up in soldier outfits in these pictures. There are no silk-stockinged legs. There are no pretty boys out of collar advertisements to suggest that this war is a gigolo party. There is no glossing over of the kind of hard ferocity that men must have to beat down the evil that is now upon us. There is no hiding of the fact that war is killing and the grim will to kill. In these designs there is none of the Pollyanna fat that the American people are in the habit of being fed.

I have made the pictures for all Americans who will look at them. They are dedicated, however, to those new Americans who, born again through appreciation of their country's great need, find themselves with new shares of patriotism and intelligence, and new wills to see what is what and to come to grips with it, in this Year of Peril.

INTERVIEW IN *DEMCOURIER*

[Publication of Demco Library Supplies of Madison, Wisconsin, and New Haven, Connecticut, XIII (February, 1943), 3–5, 20–24]

Q. Can you be objective about the people and things around you, or do you find yourself consistently evaluating them in subjective pictorial terms?

A. I am going to split this question into two parts. The first part is simple. Can I be objective about people and things around me? I can be as objective as anybody else, which is, of course, not really objective at all but sufficient for the common needs of life. The second part of the question is tough and must, itself, be divided into two parts. The first part—Do I consistently evaluate things in picture-making terms?—is again easy. Of course not. I evaluate a bowl of oatmeal, a Republican, or a stomach ache in terms suitable to their useful, pleasant, or objectionable effects on my

practical life rather than on my art. Here, again, I am like everybody else.

The last three words of this question—"subjective pictorial terms"—make the complicated part of the total question. This word cluster brings up a stack of ancient controversies. Are the "terms" of art such material things as colors, oils, varnishes, marble, bronze, textures, lines, et cetera—are they what these may be made to represent—or are the true terms of art psychological, internal, for which all the other terms are simply externalizing factors? Most people, whether they have had artistic training of any sort or not, do have aesthetic images. It is natural to suppose that art comes into being when a vehicle is developed which can "objectify" these images. This is essentially the Platonic view, where art is seen as a reflection. Most progressive thinkers seem to go along with the laymen in accepting it. My own experience allows only a partial acceptance. It is true that creative impulses originate in some kind of an internal parade of images. (Late controversies on the nature of images have not, so far, done away with the fact that somehow or other they do exist.) These images are, however, extremely vague. Few people realize how vague. Because they are sometimes accompanied, as in memory images of "the old home place," by vivid emotional feelings, they are assumed to be themselves vivid. Anyone, however, who has tried in any medium to imitate these images soon learns that there is nothing to imitate. Nothing clear, that is. As a consequence of this, "artistic" images are not so much transferred from the mind as *built up* in the artistic material. That is, constructions are made which approximately represent, rather then imitate, the internal images. Now, construction materials are objective in their character. That is true even for words when they are intelligibly used. Art becomes, then, a performance with materials which exist outside the mind of the artist—an objective performance. These materials are dynamic. They have a way of directing performance themselves. The modern formula "The means used determines the end" expresses a recognition of this in common life. It is not so well recognized in art, where you may

start with the intention to express an internal image but end with something determined, in the main, by the materials and procedures used.

This whole question is quite complicated and gets more so when the problem of the social function of art is involved. Let's end the present discussion of it by saying that the "terms" of art originate "subjectively," originate in the privacy of a mind, but have no reality outside of that privacy until they are carried over to outside (objective) materials. In the case of the painter these materials are lines, colors, shapes, et cetera. When these are combined, they call up other combinations which in the end determine the character of the work of art. The result of the play of these outside "terms," coupled with the procedure habits of the professional artist, who in practice automatically runs toward convenient "ways of doing," make the *things*, to which people respond as a work of art. The work of art is objective; it is an object. The "terms" which produce it are objective and must be seen objectively to be intelligently manipulated. The object of art may, and if it is effective, does, produce subjective effects in the beholder. So art begins and ends subjectively, in private happenings. The "terms" of its making, however, are external and materially real. This is my practical view of the matter.

Q. By what "ism," if any, do you characterize your art?

A. I do not characterize my art by any "ism." I have been called an advocate of regionalism. This is a word, however, without much meaning, a typical art critic's refuge which saves him (or her) the bother of thinking. The subject matter of my art has dealt with the whole of American culture, historical as well as actual. In representing the actual culture, it has run from coast to coast, a pretty big region. Technically and psychologically its roots reach into all the aesthetic conceptions of the historical world, from ancient Egypt and India through Greece, Renaissance Italy, and French Impressionism to those present environmental experiences which now do most to stimulate it. I would like to think of my art as representing Americanism. Maybe it

does. Those sycophantic lovers of only that which is imported dislike it enough to make me hopeful.

Q. When you see a picture for the first time, what is your mental approach to an appreciation of it?

A. My mental approach to a new picture is through curiosity. I suppose here I am like any open-minded layman. This approach, however, is promptly affected by my professional habits, which tend to make me consider the picture technically. I am of the opinion, however, that this technical interest is disadvantageous to getting the most out of a picture. Vivid emotional feelings and cold technical interests do not readily combine. The intelligent layman, fairly familiar with pictures, probably gets the best results from his curiosity. This is as it should be. Pictures are not made primarily for artists. At least they should not be, though in late years, to the detriment of the social function of art, and of art itself, a great many seem to have been so made.

Q. Do you conceive of the creative individual as one who has special privileges and special responsibilities?

A. No, for the first part. Yes, for the second. The only excuse for the artist's existence lies in his responsibility to his culture. I use responsibility here in a functional sense. The artist must respond to life and represent it. That has been his historical purpose in society. The modern retirement of the artist from society, which originated in poor, psychologically divided France and ended by his throwing off all responsibility toward the actual world, has turned a great part of modern art into perversion or near-lunacy. Anyone who reads the artistic manifestoes and critical appreciations of our metropolitan centers can recognize all the various degrees of paranoia that students of bughouse candidacy have listed. What is written about modern art is nuttier than the art itself. Even when reasonably sane, it is shallow and ignorant. Triviality is the price which has always been paid for retirement from life, for the shirking of responsibility to the world of men and to the culture men have made.

Q. *It has been said that the creative individual is on "a plane of spiritual development above the noncreative person." Do you subscribe to this belief, and, if so, what characterizes such a spiritual development?*

A. Whoever said that is a fool. I don't subscribe to the beliefs of fools. The remark is probably compensatory, made by some self-styled creator with an overdeveloped ego who was not able to get a public. Distinction, anyhow, between creative and noncreative classes are highly artificial. The artist is not more creative than the chemist or even the businessman just because he is an artist. Creative individuals, let me add as a comment on the implication of the quotation, are almost invariably successful. They do not have to compensate for the way life manhandles them, because they have learned how to handle life. Even in the arts there have been very few Van Goghs. A truly talented failure is an extraordinary exception. Because the pictures of many artists have brought more money after they were dead than when they were alive, our commercially minded public has assumed they were lonely, unappreciated individuals who paid for the success of their art by a failure in life. This is pure myth—the outcome of a habit of judging life in terms of price. A life is successful where the power of affirmative assertion is maintained throughout it. Money has nothing to do with it. A person who maintains the power to say "Yes" to life does not have to tell people about his "spiritual superiority."

Q. *Do you think it is possible to cheapen and degrade good art by printing it on playing cards and calendars and as the background for advertisements?*

A. You can cheapen the appearance of good art by surrounding it with cheapness. Advertising toilet paper with the Venus de Milo, however, does not fundamentally cheapen the statue. Only its appearance in the advertisement is cheapened, and there the cheapness is read back by intelligent people to the mind that conceived the setup. Cheap people have cheap ideas. The adver-

tising business is full of them. In the present setup of our society there is not much to do about it. One of the horrible casualities of individual initiative is the advertising business. At the same time, there are political advantages in that initiative which are likely to make us think twice before we give it up. Best thing to do is to take a pair of scissors and cut the offensive stuff away from the reproduction of the work of art.

Q. You have given the impression that you disapprove of the physical setup of art museums. What would be your substitute method of making art available to a large number of people?

A. If all I have said on this subject has given only an impression, it is too bad for my use of the English language. I thought I was making positive statements. *168407*

Most of my criticism of art museums has been directed to the physical setup regarded in its human aspects. American museum plants are superior to anything in the line ever devised. It is not the plant but the effect of those who set up the plants and those who run them on the creative potentialities of young American artists and on the appreciative potentialities of the American public that has disturbed me. I have seen an Alexandrian, precedent-worshipping, exotic-turned psychology rise to sit in judgment on the creative energies of America. The growth of museums and museum minds in the last twenty-five years tends to concentrate American artistic attention on the dead or the exotic. This statement has no compensatory angles. I have not lacked attention, and all the museums of consequence in the country have bought one or more of my pictures. I have no axe to grind for myself. I have, however, an axe to grind for America and for the young artists growing up in America.

The museum, as everyone knows, had its birth as an institution in Hellenic days, when Greek creative energies were superseded by the collecting manias of the "parvenu" kings, nobles, and merchants who grew up in the dust of Alexander's Macedonian armies. The institution was a snob institution from the beginning in its plastic as well as its literary aspects. It was dedi-

cated to overdeveloped egos whose basic inconsequence was hidden by collected consequences of the past. The museum was set up not to the glory of art but to the glory of self-importance. As an institution it has followed the path to which it was originally directed. The museum in America is almost invariably a memorial to a cash-grabbing career. It is a monument to that self-estimated superiority which is the almost invariable curse of large-scale success at money making. It is dedicated to the snob notion that the personal possession of things which others do not have, and can not get, establishes superiority, greatness, magnificence, and the right and ability to pass judgment on everything under the sun. With such a psychological start the museum naturally drew toward itself a boot-licking army of caretakers. The typical museum man has the character of a rich man's lackey. He is obsequiously polite to wealth and the trappings of wealth, and with his lackey's soul, contemptuous of all outside their orbit. The type is well known. He cultivates precious and exotic views and digs up odd bits of useless aesthetic knowledge which give him a certain ascendency over his rich employees, who, for all their pretenses, are generally pretty ignorant of the arts and are readily fooled by cunning fakers. Added to the normal museum type are the sexually oblique characters who to ordinary snobbism add the effrontery of the pariah. These latter run to the museum business like green flies to a rotting carcass.

Now, this is a tough picture of the museum and the museum character, but though there are notable exceptions, it is a true one, by and large. The museum is a sick institution, and generally the people connected with it are sick. The matter would be of no consequence if it were not for the prestige and power which the museums and their people exert in the field of living art. The museums have become the art centers of America. They set up the judgment standards for the public by lectures and the insinuations of purchase. They influence teaching in the universities and work on the minds of the young toward a denial of the values of their own culture. Young Americans are constantly led to believe that productions rising out of their own culture are in-

ferior. They are inculcated with snob values which make them respond only to imitations of museum-enthroned precedents. They are taught that the conditions for creative activity in the arts do not exist in America. This is not always done openly, but obliquely and by insinuation. The concept of art dominating the museums is orientated about the possession of rare objects. The picture restorer who keeps those objects looking rare is more important to the museum mind than the going artist. This is particularly true of America, where the restoring trade is generally more lucrative than a creative one. The American parvenu must have his old masters slick and shiny, and in one of our great universities a whole department is given over to training young retouchers. Like those who hire them, these have generally the lackey soul which makes its bow to snobbery by looking askance at the innovations of the living. It is my conviction that this museum atmosphere is not conducive to the creative health of the United States. The museum is sterile. At its best it is history rather than life. Now, history is useful. If human beings were reasonable, it would be one of our most useful possessions. But history is a story of past living, not a pattern for present living. A knowledge or display of the history of cultural expressions of the past and of other countries does not compensate for the lack of cultural expression in one's own society. The American museums teach, openly and by implication, that they represent America's cultural coming of age. Cultural improvement is, as a matter of fact, the usual excuse for their being set up. Mr. Mellon's overcrowded museum in Washington, so falsely called The National Museum, is supposed to be a monument to American culture.[1] It is nothing of the sort. It is a history of other cultures. The expressions of American culture are barely represented in it. A culture is a living thing. It is the sum of the behavior patterns and the attached thought complexes of a living and going society. The United

[1] The National Gallery.

States Senate and the Patent Office far better represent American culture than does the Mellon Museum.

Art is not culture, but a culture outcome—one of the expressions of culture. This was recognized in America up to the Civil War. We had more genuinely American art before the Civil War than we've had since. The growth of wealth afterward and the habit of conspicuous display it generated, of which the American museum is an outcome, tended to put pretense in the place of culture. Culture became something above life rather than an affirmation of life. It remains so in museum hands.

The second part of the question asks what is to be done about this for the public's sake? How is art to be made available to the public without museums? This question is beginning to be answered partially by the emergence of events in life itself. More people see the wall decorations done by W.P.A. artists than see museum pictures. I'll guarantee that ten times more Missourians have seen the murals I painted in 1936 in the Missouri State Capitol than have been in Kansas City's museum hothouse in all its history. Further, they have been more interested. Living people are interested in living art. It is because of this fact, coupled with the fact's recognition by the daily press and the national weeklies, that I am now strong enough economically to tell the truth about the decadent situation which the museums and their backers have nursed into American culture. I can tell those mixed up in the situation where they get off. I can do that. Can the young artists, now growing up, do likewise? Part of this is your responsibility as a member of the lay public. If you continue to evince interest in a living art that expresses your own living culture, the places where it may function will automatically come into being.

FOREWORD TO *THOMAS HART BENTON*

[*Thomas Hart Benton* (New York: American Artists Group, Inc., 1945)]

I like painting today more than I ever liked it in my life. For many years I was in a constantly frustrated state about it. I worked and only got half-way to something. There was always this or that to check the free expression of what was in me.

In late years I have gained a kind of freedom. I don't stew around any more. I just go to work and do my stuff. I don't know, of course, the ultimate value of what I do. I don't care much about it. But I have a sort of inner conviction that for all the possible limitations of my mind and the distorting effects of my processes, for all the contradictory struggles and failures I have gone through with, I have come to something that is in the image of America and the American people of my time. This conviction is in me pretty deeply.

I do not pretend to represent what could be called typical of America. I have never experienced anything that I could really say was typical of this country. The typical is too much of a generality to interest me. My American image is made up of what I have come across, of what was "there" in the time of my experience—no more, no less. My historical murals, because of this, are full of anachronisms. I paint the past through my own life experiences. I feel that an anachronism with life is better than any academically correct historical rehash.

I have not yet fully conquered my craft. But I have a good grip on it, and it will never get away from me. What there is in me to do, I now know that I can do.

When I am not traveling or celebrating in some way, I work long hours—ten, twelve, to fifteen a day. Because I am not a kid any more, my back hurts sometimes from leaning over. But I have a hell of a basket of fundamental energy, and I'm still good for a lot.

Expressing the release of soul that I have come to feel, I often hum to myself when I work. I nearly always hum the same tune. It's one of these hillbilly tunes called "Prisoner for Life."

WHAT'S HOLDING BACK AMERICAN ART?

[*The Saturday Review of Literature*, XXXIV (December 15, 1951), 9–11, 38]

John Steuart Curry and Grant Wood will always claim a special place in my memories. Both rose along with me to public attention in the thirties. Both were very much a part of what I stood for and made it possible for me in my lectures and interviews to promote the idea that an indigenous art with its own aesthetics was a growing reality in America. Without them, I would have had only personal grounds to stand on for my pronouncements.

We were, the three of us, pretty well along before we ever became acquainted or were linked under the now famous name of Regionalism. We were different in our temperaments and many of our ideas, but we were alike in that we were all in revolt against the unhappy effects which the Armory show of 1913 had had on American painting. We objected to the new Parisian aesthetics which was more and more turning art away from the living world of active men and women into an academic world of empty pattern. We wanted an American art which was not empty, and we believed that only by turning the formative processes of art back again to meaningful subject matter—in our cases specifically American subject matter—could we expect to get one.

The term Regionalism was, so to speak, wished upon us. Borrowed from a group of Southern writers who were interested in their regional cultures, it was applied to us somewhat loosely, but with a fair degree of appropriateness. However, our interests were wider than the term suggests. Those interests had their roots in that general and country-wide revival of Americanism which followed the defeat of Woodrow Wilson's universal idealism at the end of the First World War and which developed through the subsequent periods of boom and depression until the new internationalisms of the Second World War pushed it aside. After the break of 1929 a new and effective liberalism grew over

the country, and the battles between that liberalism and the entrenched money groups, which had inherited our post–Civil War sociology and were in defense of it, brought out a new and vigorous discussion of the intended nature of our society. This discussion and the political battles over its findings, plus a new flood of historical writing, concentrated the thirties on our American image.

It was this country-wide concentration, probably more than any of our artistic efforts, which raised Wood, Curry, and me to prominence in the national scene. We symbolized aesthetically what the majority of Americans had in mind—America itself. Our success was a popular success. Even where some American citizens did not agree with the nature of our images, instanced in the objections to my state-sponsored murals in Indiana and Missouri, they understood them. What ideological battles we had were in American terms and were generally comprehensible to Americans as a whole. This was exactly what we wanted. The fact that our art was arguable in the language of the street, whether or not it was liked, was proof to us that we had succeeded in separating it from the hothouse atmospheres of an imported and, for our country, functionless aesthetics. With that proof, we felt that we were on the way to releasing American art from its subservience to borrowed forms. In the heyday of our success we really believed we had at last succeeded in making a dent in American aesthetic colonialism.

However, as later occurrences have shown, we were well off the beam on that score. As soon as World War II began substituting in the public mind a world concern for the specifically American concerns which had prevailed during our rise, Wood, Curry, and I found the bottom knocked out from under us. In a day when the problems of America were mainly exterior, our interior images lost public significance. Losing that, they lost the only thing which could sustain them, because the critical world of art had, by and large, as little use for our group front as it had for me as an individual.

The coteries of highbrows, of critics, college art professors,

and museum boys, the tastes of which had been thoroughly conditioned by the new aesthetics of twentieth-century Paris, had sustained themselves in various subsidized ivory towers and kept their grip on the journals of aesthetic opinion all during the Americanist period. These coteries, highly verbal but not always notably intelligent or able to see through momentarily fashionable thought patterns, could never accommodate our popularist leanings. They had, as a matter of fact, a vested interest in aesthetic obscurity, in highfalutin' symbolisms, and devious and indistinct meanings. The entertainment of this obscurity, giving it an appearance of superior discernment and extraordinary understanding, enabled it to milk the wealthy ladies who went in for art and the college and museum trustees of the country for the means of support. Immediately after it was recognized that Wood, Curry, and I were bringing American art out into a field where its meanings had to be socially intelligible to justify themselves and where aesthetic accomplishment would depend on an effective representation of cultural ideas, which were themselves generally comprehensible, the ivory-tower boys and girls saw the danger of their presumptions and their protected positions. They rose with their supporting groups of artists and highbrowish disciples to destroy our menace.

As I have related, I profited greatly by their fulminations, and so, for a while, did Wood and Curry. However, in the end they succeeded in destroying our Regionalism and in returning American art to that desired position of obscurity and popular incomprehensibility which enabled them to remain its chief prophets. The Museum of Modern Art (the Rockefeller-supported institution in New York) and other similar culturally rootless artistic centers, run often by the most neurotic of ladies, came rapidly, as we moved through the war years, to positions of predominant influence over the artistic life of our country.

As the attitudes of these cultist groups were grounded on aesthetic events which had occurred or were occurring in cultures overseas, their ultimate effect was to return American art to the imitative status from which Wood, Curry, and I had tried to

extricate it. The younger artists of America were left, in this situation, only with an extenuating function. The sense of this humiliating state of affairs led many of them, and notably some of the most talented of my old students, to a denial of all formal values, and they began pouring paint out of cans and buckets just to see what would happen, or tying pieces of wire to sticks and smacking them around in the air in the name of a new mobility. This American contribution to "modern" aesthetics, though it suggests the butler trying to outdo his master's manners, received wide applause in our cultist circles, and it went out from there to the young ladies' colleges and to the small-town art schools and into the minds of all those thousands of amateurs over the land who took themselves to be artists. These latter saw immediately the wonderful opportunities for their own ego advancement that this "free expression" afforded, and they embraced it enthusiastically.

Now all this anarchic idiocy of the current American art scene cannot be blamed solely on the importation of foreign ideas about art or on the existence in our midst of institutions which represent them. It is rather that our artists have not known how to deal with these. In other fields than art, foreign ideas have many times vastly benefited our culture. In fact, few American ideas are wholly indigenous, nor in fact are those of any other country, certainly not in our modern world. But most of the imported ideas which have proved of use to us were able to become so by intellectual assimilation. They were thoughts which could be thought of. The difficulty in the case of aesthetic ideas is that intellectual assimilation is not enough—for effective production. Effective aesthetic production depends on something beyond thought. The intellectual aspects of art are not art, nor does a comprehension of them enable art to be made. It is, in fact, the overintellectualization of modern art and its separation from ordinary life intuitions which have permitted it, in this day of almost wholly collective action, to remain psychologically tied to the "public be damned" individualism of the last century and thus, in spite of its novelties, to represent a cultural lag.

Art has been treated by most American practitioners as if it were a form of science, where like processes give like results all over the world. By learning to carry on the processes by which imported goods were made, the American artist assumed that he would be able to end with their expressive values. This is not perhaps wholly his fault, because a large proportion of the contemporary imports he studied were themselves laboratory products, studio experiments in process, with pseudo-scientific motivations which suggested that art was, like science, primarily a process evolution. This put inventive method rather than a search for the human meaning of one's life at the center of artistic endeavor and made it appear that aesthetic creation was a matter for intellectual rather than intuitive insight. Actually this was only illusory, and art's modern flight from representation to technical invention has only left it empty and stranded in the backwaters of life. Without those old cultural ties which used to make the art of each country so expressive of national and regional character, it has lost not only its social purpose but its very techniques for expression.

It was against the general cultural inconsequence of modern art and the attempt to create by intellectual assimilation that Wood, Curry, and I revolted in the early twenties and turned ourselves to a reconsideration of artistic aims. We did not do this by agreement. We came to our conclusions separately, but we ended with similar convictions that we must find our aesthetic values not in thinking but in penetrating to the meaning and forms of life as lived. For us this meant, as I have indicated, American life, and American life as known and felt by ordinary Americans. We believed that only by our own participation in the reality of American life—and that very definitely included the folk patterns which sparked it and largely directed its assumptions—could we come to forms in which Americans could find an opportunity for genuine spectator participation. This latter, which we were by the example of history led to believe was a corollary and, in fact, a proof of real artistic vitality in a civilization, gave us that public-minded orientation that so offended

those who lived above—and believed that art should live above—
"vulgar" contacts. The philosophy of our popularism was rarely
considered by our critics. It was much easier, especially after
international problems took popular press support away from us,
to dub us conventional chauvinists, Fascists, isolationists, or just
ignorant provincials, and dismiss us.

When we were left to the mercies of the art journals, the
professors, and the museum boys, we began immediately to lose
influence among the newly budding artists and the young stu-
dents. The bandwagon practitioners—and most artists unhappily
are such—left our Regionalist banner like rats from a sinking ship
and allied themselves with the now dominant internationalisms
of the highbrow aesthetes. The fact that these internationalisms
were for the most part as local as the forms they deserted never
once occurred to any of our bandwagon fugitives.

Having long been separated from my teaching contacts, I
did not immediately notice the change of student attitude which
went with our loss of public attention. But Wood and Curry,
still maintaining their university positions, were much affected
and, in the course of time under the new indifference and some-
times actual scorn of the young, began feeling as if their days
were over.

It was one of the saddest experiences of my life to watch
these two men, so well known and, when compared with most
artists, so productive and so enormously successful, finish their
lives in ill health and occasional moods of deep despondency.
After the time we came to be publicly associated in the early
thirties, we had, for all our differences, developed a close personal
friendship; and this loss of self-confidence by my friends was
disturbing to me. It was, as a matter of fact, sort of catching, and
I had more than a few low moments of my own.

Wood and Curry, and particularly Curry, were oversensitive
to criticism. They lacked that certain core of inner hardness, so
necessary to any kind of public adventure, which throws off the
opinions of others when these set up conflicts within the person-
ality. Thus to the profound self-doubts, which all artists of stature

experience, was added in these two an unhappy oversusceptibility to the doubts of others. Such a susceptibility in times of despondency or depression is likely to be disastrous. It was most emphatically so for Wood and Curry.

Small men catch the weaknesses of their famous brothers very quickly, and in the universities where Wood and Curry taught, there were plenty of these to add their tormenting stings to the mounting uncertainties of my two companions. Oddly enough, although my wife Rita and I tried hard, our friendly encouragements never seemed to equal the discouragements which Wood's and Curry's campus brothers worked up to annoy them. Wood was pestered almost from the beginning of his university career by departmental highbrows who could never understand why an Iowa small-towner received world attention, while they, with all their obviously superior endowments, received none at all.

By the time we moved over into the forties, both Wood and Curry were in a pretty bad way physically and even psychologically. They had good moments, but these seemed to be rare and shortlived. In the end, what with worry over weighty debts and artistic self-doubts, Wood came to the strange idea of changing his identity. He was a man of many curious and illusory fancies; when I went to see him in 1942, as he lay dying of a liver cancer in an Iowa hospital, he told me that when he got well he was going to change his name, go where nobody knew him, and start all over again with a new style of painting. This was very uncanny, because I'm sure he knew quite well he would never come out of the hospital alive. It was as if he wanted to destroy what was in him and become an empty soul before he went into the emptiness of death. So far as I know, Grant had no God to whom he could offer a soul with memories.

John Curry died slowly in 1946, after operations for high blood pressure and a general physical failure had taken his big body to pieces little by little. He made a visit to Martha's Vineyard the autumn before he died. Sitting before the fire on a cold,

grey day when a nor'easter was building up seas outside, I tried to bolster his failing spirits.

"John," I ventured, "you must feel pretty good now, after all your struggles, to know that you have come to a permanent place in American art. It's a long way from a Kansas farm to fame like yours."

"I don't know about that," he replied. "Maybe I'd have done better to stay on the farm. No one seems interested in my pictures. Nobody thinks I can paint. If I am any good, I lived at the wrong time."

This is the way my two famous associates came to their end.

PAINTING AND PROPAGANDA DON'T MIX

[*The Saturday Review*, XLIII (December 24, 1960), 16–17]

Can the creative artist help promote peace in the world? Beyond picturing doves flying around with olive sprigs, is there anything he or his works can do to ease prevailing tensions?

All are agreed that art is a universal property. We think of the artist as one who operates in a field of universal values. The basic elements of his creations are the same everywhere and should everywhere elicit somewhat the same kinds of response. Perhaps a dissemination of pictures and sculptures might help persuade men, before it is too late, to regard the situation they have come to in the way works of art are presumably regarded, without suspicion or passion.

The artist is certainly a man of peace. Without peace, or that minimum amount of it which permits aesthetic reflection, he cannot create and the purpose of his life is nullified. What better advocate of peace than he who loses all by the lack of it? Or what better symbol of world understanding than the artistic object which would seem to speak of what all men feel?

Primary responses to art must rest on its form, and those who are close to artists know that the creative process is largely directed to perfecting the material relations that reveal form. This constant concern with purely aesthetic elements lends to the creation of art a certain autonomous character. It seems to develop in a world apart from the pressures, passions, and prejudices of everyday life. It is precisely, I believe, on this apparent autonomy, this sort of spiritual disengagement, that people put their faith in art's influence for world good and call upon the artist to sign up and help promote it.

But while relations of a purely aesthetic and at least momentarily disengaged character do and must come first in making art and in initiating response to it, they do not account for all that art involves. Concern with aesthetic values is certainly a condition of art both creatively and receptively; but when the forms of art become significant factors in man's social life, they are not only aesthetic but expressive. As expressions they are tied to other than aesthetic ideas and beliefs which operate on the artist during creation and on the spectator afterwards.

All men who do not think they can profit by war want peace. But they generally want a peace that will sustain the thought patterns under and by which they habitually live. Without these patterns—their spiritual sustenance—they are lost. The artist is here no different from his lay brothers. He is even more likely to be tied to what is familiar than they, for he is at his best when he does not have to think but can operate spontaneously on what he already knows.

But the art object is not a mere vehicle for messages that could be transmitted as well in another vehicle. Without suffering a disastrous loss of aesthetic appeal the forms of art cannot state meanings precisely or didactically, or impose them as a tract or a cartoon does. The meanings of art are, rather, evoked. Its social effects are drawn from the spectator, and with his willing participation. Art thus expresses, when it fulfills its social function, the spectator as well as the artist.

This suggests that unless the meanings contained in the art

object have some prior existence in the social body to which the artist belongs or appeals, his creations will fail to function. You cannot evoke what does not exist. Certainly, in the great periods of artistic creation the artist was at one with his society and made his images in the aura of its meanings.

In apparent opposition to this historically proved necessity of functionable art, there arose in the last century the theory of "Art for Art's Sake." Essentially this theory merely restated the well-known fact that an artist must have artistry, must observe, that is, the primary aesthetic requisites of his trade. Lately, however, this quite proper reemphasis of time-honored values has taken a curious twist. The aesthetically moving properties of the materials of art have come to be exploited for the sole purpose of promoting self-awareness on the part of the artist. To observe and enjoy oneself performing becomes the reason for performance, and the accompanying heightened sense of the self becomes the end of art. A picture is not changed to better it but only because the changing allows further realizations of the self action.

Such aesthetic operations need not eventuate in form, and generally they do not unless the word form is to be used for any conglomerate. Where, by chance, comprehensible relations do materialize and form of a sort is achieved, it does not—and, as above indicated, is not intended to—communicate or suggest any public meanings. In fact, the very nature of such operations indicates a scorn for these. But, paradoxically, they pose publicly significant questions just the same. For instance, in view of the fact that art has been tied historically to the meanings of the culture from which it arose and that the historic purpose of aesthetic formulation was to reflect these, are we to assume that the present vogue for "abstract expressionism," "action painting," and other similar contentless movements indicates that our culture has no meanings? Do our institutions, our activities, and our environments provide no substance for aesthetic creation? Or, because we have for so long had so little public use for the artist, have we atrophied his sensibilities to public values? Or are

our artists themselves at fault? Are they in pathological flight from our meanings because they lack the power to adjust to them?

However these questions may be answered in the future, the fact that they can be asked indicates that the will to perform as pure aesthete does not entail the power to do so. Even the most withdrawn aesthetic play will be affected by meanings. The artist who takes pride in avoiding his own cultural meanings may well find himself saddled with others less attractive.

Let us suppose that in the interest of improved cultural relations we should present the papas of the Kremlin with a Jack Pollock drip. This painting, representing nothing whatever, would not seem to carry any specifically, and thus provocative, American content. But it would mean something supposedly characteristic of America just the same and would probably elicit an acceptance speech decrying the antisocial indulgences of a decadent individualism. But on the other hand, a Tom Benton history, while it might find some approval for its figurative aspects, would be equally abhorrent as a false and misleading glorification of imperialistic adventurism. Both drip and history would thus have evocative properties other than what was intended by their creators.

In this hypothetical case the men of the Kremlin have not acted abnormally but as men have always reacted to objects of art. They attributed meanings of their own to them. If these meanings made the very forms of art obnoxious, that, too, would not be unusual. How many great and beautiful Greek statues went under the sledge hammers of early Christians because evil meanings were attributed to them? And how do we react to the products of Russian "social realism"? Art, then, is not really autonomous, and never was.

Here we come to the heart of our original questions about the effectiveness of art and artists in our quests for peace. The rival thought patterns by which men live all contain truths— practical truths, which are definable, and emotional truths, born of the human soul's urge to make itself at one with life, which

are not. The arts attached to and growing out of these patterns largely reflect the latter. These, along with the aesthetic forms encompassing them, even when they are patently of time and place, may well be truly universal. But to be universally recognized as such, they must be disassociated from the power complexes which are also concomitants of man's thought patterns and which are developed to sustain them. This separation can occur only when the truths of rival systems are reconciled in larger systems with larger areas of tolerance. The artist can do nothing about this. Furthermore, since peace is contingent on the same kind of reconciliation, he can do nothing about it, either. Neither can his art.

THOMAS HART BENTON ON ART

[*The Midwest Journal*, VI (Fall, 1954), 64–76. Mr. Benton was guest speaker on April 30, 1954, at a meeting of the National Conference of Teachers of Art in Negro Colleges that was held at Lincoln University and moderated by James D. Parks, Chairman of the Department of Art of that university.]

MR. PARKS: I take great pleasure in introducing a great artist, a great humanitarian, and a great Missourian, Thomas Hart Benton.

MR. BENTON: We have an intimate gathering here, so rather than a lecture I think we should have a sort of discussion. Can you hear me in the back of the room if we start discussing things? Or should I talk louder? You can hear me?

It was my understanding with Mr. Parks before I came down here that we were going to sit around a table in the library, and a few questions would be put to me and I would try to answer them. I don't see why we can't carry that plan out right here in this hall. I don't know what your artistic interests are. So, in

order to get started, in order to get me connected with you, let's have a question. I don't care what kind it is, but it ought to deal with the general subject of art—ought to be related to art, anyhow. Has anybody got anything he wants to talk about?

Q. What am I supposed to look for in art; what makes it good or bad?

A. What are you supposed to look for in art? Well, for the first part of the question, I would say that you should look for something you like. The second part of your question seems to mean, how do you tell good art from bad art. Well, I would say generally that the art that was good for you would have to be called good art—at least for you. You have to look into your own mind for the answer to that. And you should have the courage to uphold what your mind tells you is good art. There are no criteria I know of which makes one kind of art better than another in any absolute fashion. Is that an answer? O.K. Now you are left free to enjoy anything you want to (laughter)—and I think that's where you should start.

But to elaborate a little. After you start enjoying artistic things, you are likely to have changes of taste. You may get tired of certain kinds of artistic things and go to other kinds, looking perhaps for something you won't ever get tired of—looking for your "masterpiece."

But there is no such absolute masterpiece. You can get tired of very great things, the very greatest. So, the way you'll find what is ultimately good and bad for you is by a progression of interests over the years. You'll change your ideas of good and bad many times, if your interests are serious. Let's take another question.

Q. What contributions have regional art made to universal art?

A. If you know your history of art, you will find that practically all the great art of the world is to some degree regionalistic. The effects of regions—cultural climates and the general ideas built up in them—have been prime factors in making the arts of the world

different from one another. There are many regional arts. For instance, there is one right below us in Mexico. There was one there before the Spaniards came over. Each of these regional arts has made a contribution to what you call an artistic universal. If you are asking what contribution the late, so-called regional arts of the United States have made to such an artistic universal, you'll have to wait a little while for your answer. It takes quite a bit of time to determine the ultimate value of artistic movements.

Q. *I would like to know, when a juror judges a picture which an artist has sent for exhibition and it's "torn up" and sent back or kicked out, is it necessary for the artist to do that picture over, or should he let it stand?*

A. I would say that if you are the artist, it depends altogether on your opinion of the juror. If a jury sent a picture back to me, I would most certainly not do the picture over. You know when a man is judging—when he is put in a position where he has to make snap judgments about works of art—nine-tenths of the time he's wrong. I have served on many juries, and after looking at a great lot of pictures, I find that you don't know one from the other. You get too tired. I remember very well one jury turning down an entry of one of the most respected painters in the United States. Later on, somebody found the painting in the rejected pile, and we managed to bring it back into the exhibition. To our tired minds a good picture had looked like a piece of trash. So, you can't depend too much on the judgments of juries. They can be mistaken. If you like your picture, I don't believe I'd tear it up merely because some jury didn't like it.

Q. *Mr. Benton, does the public have the right to criticize the symbols of a mural or maybe erase it off the wall?*

A. Well, that's an interesting question. It boils down to whether the public has the right to destroy the work of an artist. That's an interesting question. It was never, in ancient times or medieval times, believed that an institution which didn't like a picture didn't also have the right to get it out of the way. We have

innumerable cases in China, for instance, where temples were redecorated and things we now recognize as great works of art were destroyed, or painted or plastered over. The iconoclastic movements of Byzantium destroyed beautiful and precious works by the thousands. And it is also well known that Michelangelo had no compunction whatsoever in having Pinturicchio's frescoes destroyed in order to replace them with some of his own.[1] The question of the property value in works of art is a difficult one to decide even today. Current educated sentiment seems to be with the artist—that is, if the artist puts his soul into a thing, it is believed the average buyer hasn't the right to destroy it—but I don't think this matter has ever been legally worked out. Certainly, if the majority of the people in a community object to a mural, I really don't see what the artist can legally do to keep them from boarding it up, or tearing it down, or doing whatever they want with it. You have a case of that right now in Mexico City. Diego Rivera painted a mural for a hotel down there, in which he stuck some wording which was offensive to the Catholic Church. Now, it seems that in opening public buildings in Mexico—a building such as a hotel—they must be blessed by one of the bishops of the church. With the wording Rivera put in his mural, the bishop refused to bless the opening of the hotel and the picture was promptly boarded up. Even in Mexico, where an artist has a rather high position in society relative to his position in ours, it has been impossible, so far, for Rivera to get the boards off. They haven't actually destroyed his painting, but it is obliterated for the time being. The question of art and property is difficult. Has the community the right to get rid of something it doesn't like? Well, generally, even in the most liberal society, I'd say the answer would be "Yes." I can't give you a positive statement about this business, because it has never been legally ruled upon as regards works of art.

[1] This was done when Michelangelo created the "Last Judgment" in the Sistine Chapel.

Q. Can works of artists be copyrighted?

A. There are such things as copyrights, yes, for works of art. You can copyright a painting so that nobody else can make reproductions of it or use it without your permission. You can copyright all sorts of things, illustrations and the like. That's done all the time, but when a community—I think you are still talking mainly about the status of a mural—orders a picture and the community as a whole decides that the picture is obnoxious, I suspect that the community has the right to destroy or remove it, copyright or not.

Here's a case in point. Right now, the question of whether it is good or bad for the community to permit the circulation of comic books—the more bloody variety—is being agitated. Now, comic books are works of art, in a way. Well, I would say, even where they might be "good" art, that they ought not to be circulated. Now, if that's true in the case of comic books, it's true in other cases. The community must in the end decide what is good for it. I don't know how you can keep it from doing so without resorting to dictatorship.

Q. Can you separate a work of art from its content?

A. Yes. We artists are constantly separating our forms from their content. We think very frequently in terms of form alone. Sometimes we completely forget our content because of our interest in our forms. However, the way a work of art operates on the public is through a combination of form and content, and there I think it is exceedingly difficult to separate the two. The meaning of a work of art is first had, of course, by response to its form. You see the work and then see its meaning. Actually, even for artists, the separation of the meaning from a form can only be done completely when the work of art has no meaning. You know, of course, that forms can exist without meanings, or without particular meanings. Making such forms is very popular today; but when you have forms which do carry meanings, it is difficult to get them completely apart. However, we must qualify

that statement. For instance, it is well known that many early Christian symbols were borrowed Greek symbols, with their meanings changed. For instance, the symbol of Orpheus would become that of Christ. The symbol, picture, statue, or mural painting would retain its Greek formal attributes but had to have a new name written on, so that a whole new set of meanings, very un-Greek, would be attached to it. Thus, there can be a separation of meaning from a form. Generally, however, a new meaning is injected. I think something like that goes on constantly. Forms can, and do, enclose new meanings in different times and places.

Q. I was wondering about a college freshman—whether you should give him the basic fundamentals, such as drawing, color harmony, and different things like that, before you let him start self-expression?

A. Your question, as I see it, is whether you should start expressing yourself before you know anything. It depends upon the purpose of your expression, it seems to me. If you don't intend to communicate anything, I don't see that you need to know anything—just express yourself. Children do that all the time, you know, without any knowledge at all. If, however, you want to express yourself in terms which may be comprehensible and have meaning for other people, I think most instructors would agree that you ought to have a little bit of knowledge about the subject you are trying to express and about the technical means you employ.

Q. That brings up a point that came up at our conference this morning. A few of us maintain that one should accumulate certain skills and that certain knowledge should be gained before one tries to express oneself—primarily, learning to draw well— know some of the tenets of perspective, and some of the mechanics, some of the basic skills of art. Some maintain, as I get it, that such fundamentals are not needed. If one drew a face all out of shape, well, let it go, if the expression itself is won-

derful. But it seems to me that certain skills should be accumulated and certain knowledge before a person can really say anything.

A. Well, a person, even one without knowledge, may have something to say all right; and if he is only saying it to himself or for himself, I don't see why you should insist upon disciplines. But if, as I said before, he is trying to act in some communicative fashion or raise meanings in the minds of other people, I agree with you that he should be trained. However, there are lots of different ways of being trained. For instance, in the Chinese arts, in which realism, as we think of it, was not attempted, the skills developed would be different from ours. Perspective, as we see it, would not be needed. However, in general, I agree with Mr. Parks that the young artist had better take some kind of training.

Q. Do time and experience necessarily alter one's concepts of form?

A. Yes, concepts of form, like other concepts, change continually. Experience forces them to change. You begin to have forms taking shape in your mind which picture the living world the moment you are conscious of your existence. Naturally, time, plus experience, keeps changing these forms. I'm talking now about interior forms—those in your head, which describe the world to you. All such forms keep changing. So also do your ideas about artistic forms.

Q. I would like to know to what extent the present political climate affects art?

A. Well, to tell you frankly, I don't really know. A lot of the art practiced today, while it may not intend to, does reflect the general political confusion of the time. Artists, whether they want to or not, are unable to live in a complete vacuum. Willy-nilly, conditions in the world do affect them, and are reflected in their endeavors. We have now in the field of art a terrific

emphasis on individualism, which is very interesting in view of the fact that individualism—untrammeled individualism—in our economic and political life died at the turn of the century, even before that, in the 1880's. It's interesting to see reflections of the economic, political, and social concepts of another age being played up as the most progressive forces in the field of contemporary art. Actually the exaggerated individualism that the critics and art professors so love today is a lag from the general development of the world. Speaking roughly, I believe that social climate must at all times affect the arts that are practiced in that climate. If you have confusion in the arts, there is likely to be confusion in the political and economic scene. However, I must qualify that a little, because some of the periods of the greatest turmoil in Europe were periods when the arts reached their highest degree of solidity, of quietude, and of general greatness. So, nothing can be said that will be absolutely true in this case, because you always find an exception.

Q. What do you think about Picasso?

A. I never make judgments about my contemporaries. I've got enough prejudices which I show inadvertently without making them so open.

Q. What amount of training and what amount of talent do you need to be a good artist?

A. I've already spoken about the training business, so let's consider the question of talent. Talent is a curious thing. I taught in various schools for about nineteen years. I noticed, time and again, that those students who had the most talent generally took the least training, and wound up without developing the work habits necessary to success. In art, as in any trade, you get along by the habit of working. So, talent is a good thing to have, but it is no good in itself. It must be developed by work.

Q. What influence do you think an artist like Mr. Dali, a Surrealist, will have on the younger generation growing up, and do you think this is good?

A. I don't have the slightest idea. I would have to wait a while and see how that younger generation grew up to give you an answer.

Q. *Will there ever be a time when the artist will be worth enough again to society to have society pay him as they did in the Renaissance, or in Greece, or in other great periods?*

A. A difficult question, and as the one earlier, I can't answer it definitely. In the High Renaissance most painters painted for a living. They were often highly paid. Painting was a profession with a purpose—with several purposes. There was, for instance, the religious purpose, and there was also the purpose of aggrandizing aspects of the political world. The various royalties and the Popes were frequently aggrandized by artists. Paintings were made quite often for the glory of the various doges, or rulers of Venice. Art was publicly directed. Will there ever be a time, you ask, when the artist will again be worth enough to society to have society pay him as they did in these old days? As I've said, we just don't know. Right now, art follows the pattern of our Western mercantile and industrial civilization. Works of art in that civilization become dealers' items. Art functions in our society as a piece of salable goods. If an artist gets known a little bit, his goods sell better and at better prices than they would if he were unknown. Occasionally a mural gets painted which functions in society not as a dealers' item but in the way the old paintings did. There is an attempt to revive the old situation in Mexico; and to some extent it has been done. But Mexico doesn't pay her artists as well as the Renaissance did. What you're really asking is whether art can again function meaningfully in society. Art may very well be on its way out of society. Some people believe that. It has happened before. Take the case of the famous Cro-Magnon people who lived in the southern part of France in prehistoric days, inhabited caves, and made decorations all over these caves. During the life of these people there was a period—I'm not sure I'm absolutely correct about its length, but I think there was a 3,000 year interim—in which they did no

art at all. During that period, so the theory goes, all attention was devoted to material things, to progress in flint-chipping, weapon-making, and so forth. We may be going through such a tool age at the present time, in which art is not of very much consequence in society. Will art come back again? Will it become socially and publicly important again? I don't know. I doubt seriously whether it will ever come back into society in the same way as before. No period of renaissance—and there have been several—ever brings out identical situations.

Q. I was under the impression that there were two classes of art —fine art and commercial art. We were taught to believe that fine artists painted for the sake of art. What is the difference here?

A. I think we ought to look closely at what you call commercial and what you call fine art. Is a work of fine art commercial when it gets in the hand of a dealer and is used as an object in mercantile traffic? It certainly is. It is just as commercial in that form as the stuff which is made for soap manufacturers' advertising. But this works in reverse also. Often works which are primarily commercial become fine art. I happened to be in Pompeii last year. In the Naples museum there are thousands upon thousands of articles which were purely commercial when they were made, but which we now call works of art. Some of them are obscene articles, but they are still called works of art. They were made for the same kind of low, comic-book mind that we have today. And yet today they are installed in a museum, and you look at them and you know that they are in fact works of art.

Q. I'm interested in the present-day question of obscurity. The average layman finds it in so much modern art. The same complaint is made, of course, in the field of literature. So much of our modern poetry is obscure, because the idioms are obscure. Do you think that is a good thing? Could we say that the trouble is that we need schools to educate people up to the point where they can learn the meanings of modern art?

A. May I ask you a question? If there is no meaning in such art, how could anybody be educated to find it? And possibly there is no meaning.

Q. *I'm very humble about this thing. I simply ascribe it to my failure to understand certain things due to my ignorance, and I—*

A. That's generous. Most people don't admit to any ignorance.

Q. *Anyhow, my question is whether this obscurity is a good thing for art.*

A. I believe what you are asking is this: If the nonrepresentative-pattern art so popular at the moment fails to give you meaning, should you get next to some highbrow who has made up a meaning for it, and take his?

Q. *See if I can get some meaning? From him?*

A. Well, people do just that. However, modern nonrepresentative painting doesn't necessarily have or need a meaning. You know you can get a kick out of red and green being together— just together. Mere patterns can get along by themselves quite easily. Our grandmothers made them with quilts, highly abstract patterns, and nobody hired a highbrow to find special meanings for them. You didn't, in grandmother's day, ask a quilt to represent the macrocosmos or anything like that. You were satisfied that it was just a nicely patterned quilt. If you will look at our modern things and be satisfied with their quiltlike character, you can get as close to their essence as anybody, all right. If you can't get any pleasure out of them, disregard them. If you don't like a particular brand of art, turn your back on it. It isn't for you.

Q. *One poet says, "The poem doesn't mean; it is."*

A. Unfortunately I don't read much modern poetry, but that which I have read leads me to agree emphatically with your poet. I can probably find more in a painting that has no meaning than I can in a poem that has no meaning, because I can see whether

a painter has a gift for color or not; I can see whether he is crude and has no business painting or whether he has a talent, even though misguided. Our current modern movements have their histories. The growth of obscurity in modern art is not a sudden growth even though it appears irrational at times, as with Cubism which began with cubes and ended up with flat patterns. Besides irrationality, we have among the moderns some plain cynicism. One of its forms, which appeared right after the First World War, was called *Dadaism*. That movement permitted all things, if they amused. It was symbolized chiefly by putting a mustache on the "Mona Lisa." That was actually done, and the copy was presented as a work of art in Paris. Or making something like a fur-lined teacup. That also was done and exhibited as a work of art. Well, this sort of stuff is often very amusing, and we are still in a society where they don't cut your head off for having fun. We are undoubtedly in some kind of a transitional period, perhaps a decadent one. That would be hard for me to know. Something might grow out of our period, as one of you gentlemen suggested a moment ago. Out of a period of complete denial of values might come a new period of affirmation. The world seesaws that way. There is apparently now among many young painters a curious return to what we call naturalistic realism, which you didn't think would have ever returned. I mean the kind of realism which was followed in the sixties and seventies, especially in Germany and also here in America. In spite of all that's been said about the development of the camera and how it has superseded realism in painting, this old naturalism is seeing a revival. Old forms, as a matter of fact, have always been revived, so perhaps we should not be too surprised at this one.

Q. *What is your feeling about African sculpture?*

A. African sculpture is now considered one of the original arts of the world. For me it's a very interesting art. I was thinking about African sculpture when I came over here today. I began first to think about a movie of Michelangelo's sculpture which I

had seen. It was a magnificent thing in which the cameraman had advantages few of us ever obtain. By the use of tripods, scaffolds, and ladders he had been able to produce rapid sequences of movement over and around the sculptures, so that you grasped their totality and their movements in space. I realized how completely three-dimensional these carvings were and that there was nothing like them in the world. When the moving camera played over them, they appeared to move back and forth themselves in a world of great depth. Then I began to ask myself if there was anything comparable to this in the history of art. Well, the nearest thing—in a much more primitive fashion, of course—I could think of were the form sequences in some of the African sculptures. These are also made in a "total round" where one plane sequentially follows another. The African artists made things as if they had to be felt as well as seen. And it's very possible that in the religious usage of some of those things they had to be felt, nursed, and petted as if they were living things.

There has been a great fad for African sculpture. It began in Paris before the First World War; in fact, so great was the fad that enormous amounts of fake African objects were manufactured in Germany and sold to collectors. It is interesting that those modern artists who have tried to follow the patterns of African sculpture have turned them into something flat. They have never made the kind of thing which operates sequentially in depth with each plane following another around and around.

Q. Do you think the idea of symbolism that the Africans used in their sculpture could be thought of as like the symbolism of contemporary art?

A. Well, I don't see how their symbolism would have much real meaning for today. I think you would have to return to the mental state which built up African sculpture to believe in their symbolism. Nevertheless, it is possible to learn from them as from other arts. You can learn about sequential relations of planes in depth, for instance, as I've said. Nobody would think

of a Michelangelo sculpture as being *like* a piece of African sculpture. Yet there is a relationship—a technical relationship. But to get back to symbolism and the meanings of African sculpture. Specialists in Negro anthropology no doubt understand a good deal of this. I do not. But that does not keep me from enjoying the sculptures as works of art. I can read my own meanings into them. After all, the purpose of a work of art is not exactly to deliver meanings to you but to produce something which will stimulate you to make meanings yourself. And there are such things as aesthetic meanings. You can like things without understanding their symbolism just because they have a kind of beauty.

Q. *Isn't that the way you appreciate modern paintings?*

A. Oh yes, and that is partially true of all paintings. The only difficulty with appreciating a great deal of modern painting is that the private meaning of some critic is put in literary form and then read out as a universal meaning which people feel they must accept to be "in the know." You should make your own meanings if you want to get real values out of art.

Q. *Can symbols be imitated?*

A. Certainly, works of art which have symbolic values can be imitated.

Q. *Could you actually say that such imitation would produce a work of art?*

A. I don't see how you could. It would produce an imitation which might, of course, be artistic, but would not be creative. Producing art is creative.

Well, shall we quit on that?

ART AND REALITY: REFLECTIONS ON
THE MEANING OF ART IN THE SOCIAL ORDER

[*The University of Kansas City Review*, XVI (Spring, 1950), 198–216]

"What has art to do with the realities of American life?"
Sooner or later in every discussion I have come into with prac-
tical American men and women, this essentially suspicious ques-
tion has arisen in some form. It is a plaguing one to face
squarely. But it is a characteristic and fundamental American
question, a natural outgrowth of the traditions of practicality and
realistic temper in which most Americans have grown up.

Although posed with specific reference to America and to
our national mythologies, the question has a universal character.
In this time-honored form it becomes, "What has art to do
with reality?"—not just American reality but all reality. That
there is a correspondence between art and what men have re-
garded as real is continually testified to throughout history. In
one way or another, art permeates the whole life of mankind.
In spite of periods of decadence and times of abandonment and
occasional outright repudiation by various social-political and
religious powers, it has persistently appeared and reappeared
through the centuries. This would not be, had art not in itself
some basic kind of reality. Without the possession of this, it
could not have survived all the different conceptions of the
nature of reality which at different times and places men ac-
cepted and lived by. Where does this particular artistic reality
lie which seems to accord itself with nearly all of man's different
ideas of the real and which in fact persists when many of these
are no longer believed in?

Just as my practical American friends have been asked for
art's reality in reference to our American world, so, no doubt,
did their parallels in ancient Egypt, Babylon, and Crete ask for
it in reference to their worlds. We have no record of what these
men of old concluded, though it must have been largely favor-

able to art, because it is mainly through the art they sanctioned and used that we know of their existence.

It is not, however, in the very ancient world but in the later world of Greek civilization that we must look for our first answers to the question. Here there are records to read.

The Greeks said that art was a form of imitation. They believed that the power and effectiveness of art lay in its reflective capacity. Its reality, they said, was a reflection of what appeared as real in life. It was a mirror held up to the world of man's being. It affected men because in it they saw and felt a heightened quality in the real substance of that world. This seems a quite simple definition of art's reality—too simple almost to be adequate.

When all their accomplishments are considered, however, and in spite of their various social failures such as their sanctioning of slavery, the Greeks were probably the most completely civilized people who have ever lived. This is pretty generally admitted. What they had to say, therefore, cannot be lightly disregarded. They were among the most artistically productive of peoples, and they were also the profoundest of thinkers. Through their philosophers they thought not only about art, but about almost all the basic problems which still confront humanity. In spite of our modern scientific knowledge, we have not improved upon the Greeks in the fundamentals of straight thinking. It has even been said that the better part of our modern thought is still a commentary on theirs. The Greeks thought clearly even without the elaborate experimental techniques, statistical checkings, and laboratory proofs we use in trying to think today. Their language was simple, generally as simple as that used in describing art. It was simple even when the ideas it enclosed were complex and difficult. The Greek philosophers are, to date, about the only philosophers who can be read without a lifetime course in jargon. They are the best resource, therefore, for those in search of basic meanings who are not professional philosophers. Whether they answer their problems in a wholly satisfactory way for the

modern mind, they at least state them so they can be under-
stood. This is especially true of the problems of art.

There is no mistaking what the Greek philosopher Plato
means when in his great work, the Republic, he tells us that the
artist is "he who makes not only vessels of every kind, but plants
and animals, himself, and all other things." It is utterly plain
here that whatever else the artist may be, he is a fabricator first
of all. He is a craftsman like the potter or the carpenter—he
makes "vessels" of every kind, and "likenesses of things."
Plato says that the substance of what the artist makes may be
had by "turning a mirror round and round." Although in this
particular context the philosopher is speaking, possibly, in a
somewhat satirical vein, he does provide a pointed and clear
definition of art itself. In this definition, seen in its overall form,
art is a mirrorlike or reflective fabrication, turned on the world
of experience.

Elaborating further on this fabrication and with a poetic
pleasure which conflicts with his satirical undertone, Plato says
that it reflects "the earth and heaven and the things which are
in heaven or under the earth." Even the gods are included in
what art's mirror can reflect. All of this constitutes a pretty big
order of reflective capacities. Although Plato is later prepared
to throw artists, like lawyers, out of his ideal Republic, because
he sees their "illusory" passions and interests as disruptive to a
moral order of things, he nevertheless gives to art itself an
immense range of powers—greater, I believe, than any thinker
on the subject would give today. Few would now say that art
possesses or ever possessed such illusory capacity as to be mis-
taken for a mirror turned on the world.

For the average Greek citizen, however—with the startling
objectivity of his painted sculptures in mind, with such stories
as that of the picture of Apelles, where the birds came to peck
at painted grapes, in mind also, and with a consideration of the
Greek acceptance of the peculiar "realities" of their stage—it is
easy to believe that Plato's assumption of art's illusory power

would have seemed reasonable. What appeared to be real, even though clothed in artistic conventions, was real for the imaginative and susceptible Greek. Whether or not he accepted Plato's final judgments about the evil social effects of art's likenessess, the average Greek citizen would, no doubt, have accepted his notions as to their effectiveness and illusory power. Art reflected vividly what existed—man and his world and the gods and their world and all that went with these. It reflected them in what was taken to be so lifelike a way that the reflection could be substituted for the reality—just as later on, in stories of the Catholic Church, we hear of statues of the Savior or of the Virgin being substituted at times for the spiritual realities they represented. Simple people transfer very easily to fabricated objects the realities or supposed realities these stand for. Such essentially magical transfers continue, I am told, even to this day in neighboring Mexico. In Greece, where an advanced civilization was in close touch with primitive and barbaric conditions and was constantly affected by these, and in very intimate ways, through the household slave trade, it is plain that distinctions between the real and the approximately real would be highly variable and, in the simple popular mind, not under very rigid criticism. The reality of art's images was, without doubt, quite fully accepted in Greek society.

With his predominant interest in social morality, Plato would never have directed so much of his attention to art if art had not itself been a profound social fact in the life of his time. Plato saw what a truly living thing it was to the sensuous Greek citizen and how that citizen took its images to be true images. The statue of Pygmalion, which turned to life, was thus something more than a story. Pygmalion's experience was continually occurring in the emotional responses of the vivid and sensuous Greek people.

Plato, like so many of those who look dubiously at art today, had in him something of the squeamishness of the Puritan. He came toward the end of Greek expansion, in a time of social upsets and wavering mores. The questions that were in him,

like the poetic flights of imagination he yielded to, were, in grosser forms, probably also in the whole body of Greek society. Anarchies and tyrannically enforced disciplines alternated and raised social questions similar in many ways to those we face today. Luxurious wealth, hopeless poverty, cunning legalities, ambitious politicians grasping for bits of power, revolutionary demagogues seeking to destroy power, paraded across the Greek scene with strange, mysterious, and half-barbaric religious cults in which hypnotic illusion and sensual ecstasy played large parts. In this atmosphere, serious-minded men such as Plato and Socrates, for whom he was a mouthpiece, were compelled to hunt for some overall kind of "truth" which might resolve and settle things. Socrates and Plato were moralists as well as philosophers. The instinct for reform was in them. And with them, as with some other later reformers, was a substantial measure of that narrow intractability about the illusions and emotions and inherited habits of ordinary men which make up so much of the sap of life. They were annoying, persistent, and disturbing questioners. So disturbing, in the case of Socrates, that the Athenians got rid of him.

Although Plato was poetic, possessed of mystical leanings and the highly aesthetic sensibilities of an artist, his moralistic tendencies triumphed in his thinking. In the end he took the view, made so well known by our contemporary totalitarian societies, that art was in itself a social evil and of no value unless specifically controlled in the interests of the state. Plato's views of art made it thus a propaganda instrument for the furtherance of policy. Where it fails this purpose, it becomes a positive evil.

To comprehend fully this Platonic view toward art, it is necessary to take into consideration not only Plato's moralistic tendencies but all the instability of his time, the disappointments he suffered as a politician with the rulers of the Greek colony-city of Syracuse, his certainly outraged feelings before the fact that art was highly acceptable to the Athenians while the voice of his idol Socrates was not, and the final fact that the

Greek civilization, of which art in all its forms was at the very center, was on the decline. When all this is seen, Plato's final distrust of art is more easily understood. Art was part and parcel of a society running into evil ways and was therefore evil itself. It defied illusion and helped to keep men from entertaining the "truth," the Platonic "truth," which might save them. But, in spite of himself, Plato remains very much the Greek artist. His very philosophy must unravel itself in a series of vivid scenes. He thinks with images, with pictures of wild horses and deep caves of illusion; and at the end of all his suspicious thinking about art, he remains the most sublime expositor of the spirit of art who has ever lived. In the Platonic vision of ultimate beauty, every artist must find something of that which is in his own deepest yearning and which can never be satisfied by any material production.

In spite of his ultimate repudiation of the poetic and artistic man, Plato gives to art an immense range both in the extent of its reflections and in what it may *do* to human sensibilities by these reflections. He never questions the power of art or the reality of its social effects but what he considers the untruthful and thus harmful nature of these. His final repudiation in the *Republic* is based on art's failure to reveal what is *ultimately* true. That which, like art, was tied to sensuous appearance was out of place and useless in that special world of "true" and nonsensuous ideas to which Plato was attached. Except as an instrument, it was useless in his ideal society which was to reflect, under philosophical guidance, the character of that world. Plato's denial of art is a perfectly logical outcome of his reduction of all life to a rigid moralistic-political scheme. It is one of the logical necessities of his philosophic structure which itself, as indicated, was in a large measure the outcome of the failing morals of his time.

There are moments, however, when it is difficult to believe Plato is wholly sincere. He strains his argument and turns again and again to glory in the "appearances" he is preparing to put out

of man's life. You feel there are two Platos, the puritanical
moralist who is disgusted with the way life goes and the
sensuous Greek who looks with pleasure on life and on the
images which represent it. Certain it is that in a land of mag-
nificent art the aesthetically sensitive Plato did not go about
unresponsive. The famous passage in the *Philebus* about "lines
and curves and the surfaces or solid forms produced out of these
by lathes and rulers and squares," although directed to notions
of "Absolute" beauty, must surely have had its subconscious
origin through observing these factors in the actual structures
of Greek art. Though the beauties of these structures were
relative and highly qualified in Plato's philosophical language,
their geometric relationships were physically actual and open to
his aesthetic eye. It would be absurd to think that Plato could
have missed the geometric character of proportional experiments
in Greek artistic practice when they were all about him from
his earliest childhood.

Leaving aside, however, certain evidences of inconsistency
between Plato's human and aesthetic leanings and his intentions
as a philosopher and political moralist, we have his picture of
art as a *reflective or imitative instrument possessing affective
powers in society*. It is this general definition which is significant
for the purpose of this writing. That he finally regarded art's
affective powers as socially evil is not so important for us as that
he recognized them and for the first time defined their nature.
He presents art as a fabrication of the same order as vessels which
has the power to reflect all that man can see, feel, and love in
the world of perception and imagination. He here gets at the
very center of the actual nature of art, that is, at the perception
plus craftsmanship with which it begins. The final Platonic
denial of art's value is actually a denial of the value of perception
itself as well as of art. As such a denial cannot be sustained
except by denying our common humanity and accepting the
whole of Plato's philosophy clear through to its moral and
political totalitarianism, we may lay it aside.

The doctrine that art is a reflective or imitative instrument,

however, cannot be laid aside. Since Plato stated it, it has been repeated and commented upon until it is profoundly rooted in the minds of men. People who have never heard of Plato believe it wholly. No doubt it was planted in men's minds before the Greek philosopher ever lived. I suspect that Egyptians, Babylonians, and Cretans, as well as Greeks, accepted it unconsciously and that Plato merely gave it its first clear verbal expression.

In spite of all the qualifying the definition has been subjected to by thinkers of more modern times who were disturbed by facts it did not seem to cover, it is generally accepted to this day. It crops up in every conversation about art, and every lay judgment of art's function and value, consciously or unconsciously, is based upon it. All effective arguments about my own artistic efforts, particularly about my murals in public places, have been invariably based on whether they were real or truthful images. My artist brothers in Mexico have had their frescoes scratched off the wall, not because of any geometric or color relationships there involved, but because of a passionate disapproval of the "realities" they represented. Except for a relatively few professors of aesthetics, a few museum cultists, and a handful of practicing artists, true art is now, as ever, believed to be an imitation or reflection of something real in a real world. It must correspond to what is believed to be real to be effective. Among contemporary thinkers who are of a practical turn of mind—among lawyers, politicians, economists, newspaper writers, even among priests and clergymen with institutional responsibilities—criticism of art rests on the same base. It must have correspondences of a satisfactory sort with what is taken to be the real.

The Platonic theory that imitation or reflection is the primary function of art is, then, almost universally accepted. I do not think it can be uprooted even when we recognize that there are secondary functions involved. It is in line with too much historical fact in mature artistic form and with basic imitative propulsions possessed by every child. If art is to come again into

an effective social position, the professional artist and theorist of art must needs again make large concessions to it. Its overall historical truth is obvious and is patently manifest in any comprehensive collection of objects of art.

Modern aesthetic theory, like much modern art, looks with horror on the obvious. What is clear as day seems trite. This modern revulsion against the plain and simple emanates from an artistic cultism with whose psychological and social causes I shall deal later, but which is devoted mainly to playing with all sorts of obscure and tenuous side issues. This is not to say that modern art deals only with side issues. Many of the issues of modern art may turn out to be permanently consequential, but there is a tendency in theorizing about them to prejudice this fact by attributing to them more than they can bear or by associating them with pretensions which make them seem foolish.

Modern art is not nearly so much at fault here as are the critics and theorizers who interpret it and so blow up its more obscure sides that these appear of primary importance. Modern art, when it reaches the status of significant art, is not essentially different from any other art and must find its relations to reality in plain rather than obscure facts. To answer the question with which this chapter starts, whether it refers to "modern" art or any other art, we need, in the words of Justice Holmes, "more education in the obvious and less elucidation of the obscure."

To explain what is obvious is not as easy as to accept it. This is particularly true of the imitative or reflective function of art, which, along with its general popular acceptance, also carries a train of ideas and judgments of a complicated and far-reaching nature. With the overall belief in the general correctness of the Greek definition of art, we have inherited from Plato, as well as from dozens of his successors, a mass of speculations about art's value and social purpose. These latter have obscured the basic realities of art almost as much as art's own peripheral obscurities.

I have indicated that Plato passed a negative judgment

about art at the same time that he defined it. He condemned it not because of its human reality, to which he attests, but because it failed to reflect the kind of superior reality which he, as a philosopher, envisaged as an ultimately *true* reality.

At the risk of getting much deeper into the field of philosophy than my information and training warrant, I shall have to consider this superior Platonic reality. It sticks to art in all sorts of ways and crops up continually in judgments about art not only among the educated but in naïve ways in the run of the populace.

Plato's *true* reality, we must remember, was not to be found in direct experience. It existed beyond such experience in a realm of ideas. It was beyond demonstration and could be apprehended only by thinking about it. It was in fact reached by Plato himself through a logic of grammar, through a dialectic process where verbal contradictions, played against one another, demanded explanations further and further removed from common experience. It spurned worldly appearance as illusory and misleading, and treated the senses as evil. Viewed in its rigorous totality, it was a denial of the reality of life as ordinary life-loving humanity savored it.

Along with some of the popular Greco-Oriental mysteries of the Hellenic World, of which it has been called a sort of intellectual counterpart, Plato's superior reality penetrated deeply into the thought of the early Christian Church and through that into our own modern world. With it came also a spearpoint of the Platonic suspicion about the value of art in relation to this reality. How was that which was tied to earthly perception to represent a reality which was above and beyond it? Was it proper even to attempt such representation?

Plato's morally tinctured judgments about art and reality not only penetrated Christianity but provided intellectual support for a good many of the Church's iconoclastic outbursts. They went along with the old Jewish aversion to images, proclaimed in the Second Commandment, which was inherited by Christianity and strongly felt even after the Catholic Church

had established its complete doctrine, its ritual, its temporal power, and had produced its great art. This aversion was afterwards to rise vividly in some of the Protestant rebellions against the Church.

Plato's realm of pure ideas, where alone reality could be found, was a pagan parallel to the Christian Augustine's *City of God* where alone a real truth dwelt. Augustine was, no doubt, directly influenced by Platonic thought. Perhaps all the philosophic theologians of the early Church can be called Platonists, for from the beginning they appear to have agreed with Plato that only such truth as was beyond the illusions of worldly perception was really consequential. What did not reflect such truth was likely to be tinctured with evil. There is much of Plato in late Judaic thinking, and it is possible that Platonic ideas entered the Christian Church not only directly but as a Judaic inheritance. In any case, there was among the thinking fathers of the early Church an amalgamation of Jewish and Platonic suspicion about the possibility and the propriety of representing God's reality with sensuous images.

This intellectual amalgamation, however, must certainly have had many opponents among the faithful. Did not God say in the Sacred Book, "Let us make man in our image, after our likeness." If this were literally taken, and surely there were early fundamentalists, why could God not be represented? If man was in God's image, was not God, in a way, in man's image?

Over this theoretical business the early Church must have fought some grim battles. All around the Church was a world of images believed in and loved not only by the aristocratic and aesthetic-minded pagans, but by the very common people to whom the Church in its march to power must appeal. In the shrines of the more dominant pagan religions from ancient days, statues and paintings had introduced worshippers into their final communion with the gods and goddesses. Art, human and sensuous, stood on the threshold of every temple reflecting the spiritual things within. At times, art's images became these things and received the sacrifices meant for them. Without an

image to tell about it, how could the common man know what was the likeness of God? And how could there be a God who had no likeness, no body to be reflected? What kind of a God was he who had no face, or Son of God who was only a Galilean ghost?

The Church faced a practical issue here. This issue was the life of the Church on earth. Sensibly, but with many an unrecorded internal schism, no doubt, she yielded to the human custom about, and in spite of the ancient Jewish prejudices and the infiltrations of the Greek Plato, she brought sensuously perceptible images into her temples. She yielded to art and, with it, to the old anthropomorphism which saw and imaged its gods and goddesses simply as exalted men and women. The Church's Virgin Mother became the universal mother-goddess, known in various forms and names to all the East; her Jesus, the universal Dionysiac son and bridegroom and sacrificed intercessor; and her God, the powerful and unpredictable Father of Gods who in a world fenced in by the even more unpredictable possibilities of a rising barbaric force offered an understandable, because human, hope for protection and peace. All these anthropomorphic forms could be readily visualized in terms of ordinary perception and represented by aesthetic images acceptable to the Greek-inspired civilizations in which the Church was rising. The images of the old gods of Greece, although now represented by a somewhat decadent and unskillful art, had their names changed, and entered the Church, bringing their devotees along. Artemis, Dionysus, and Apollo and the Persian Mithra, too, found a new home in the temples of Jesus.

Back in the inner sanctuaries of the learned and intellectually disposed churchly fathers, this Christian return to an open anthropomorphism was regarded, no doubt, simply as an expedient. It was a concession, as were possibly all the more pagan rituals of the Church, to prevailing human needs for aesthetic representation, for emotion-generating objects and performances. The Christian Church, seeking its early power in the warm, sensuous Hellenic-Asiatic world, had to adapt itself

to that world. Out of this adaptation came little by little the Christian arts of Alexandria, of the Roman catacombs, of Byzantium, and finally of the Catholic Church of Europe, which turned the abstract "realities" of the *City of God* into human realities of love and sorrow and devotion.

But back of this humanizing of Christianity, the Platonic view that consequential reality—in the Church's language, the reality of God—was beyond perceptual experience and therefore objective representation, remained. Art could not truly reflect that reality. There remained also the notion, submerged in the great days of the Church, but breaking out again and again, and strongly in the days of the Protestant rebellion, that because of this, art was somehow evil or trivial. The Protestant repudiation of visual imagery, particularly the Puritan repudiation, was based on this notion. In Puritan countries where art survived at all it was pushed aside as utterly inadequate in the face of God's reality. Puritanism took the practical view that as the images of art were unable to help directly in knowing God—the true reality—they were superfluous.

With the spread of Puritanism in Western Europe, the repudiation of artistic imagery as a social factor of any consequence became general. Such imagery was worldly illusion and, for serious men, could not even be accorded the symbolical values it had for Catholic thinkers, who, though they did not really believe in its power to reflect God's reality, still admitted it as an effective human symbol thereof. The Catholics said, following their sixth-century Gregory (the Great), that it was possible to learn from the language of artistic imagery what ought to be worshipped. The Protestants by and large said that it was not. They believed that each man had to learn of God and God's reality in his own secret individual soul and that no priest or communal ritual or aesthetic symbol could help. In such an atmosphere the reality of art naturally had no place. It was no more, in fact, a reality.

Protestantism in its threefold form of Lutheranism, Calvinism, and Puritanism rose with the rise of the trading cities

of Europe and with the individualistic business enterprises of their citizens. Protestantism may have been, as many hold, a function of the expansion of this individualistic activity. Its largely accepted practical view that the shortest and quickest way to get at God is the best way and that an ugly way is as good as a beautiful one certainly coincides with the practical business spirit where success alone is the ultimate human test. Whatever the generic relations between Protestantism and the changing world in which it was born, the success of its final Puritan emphasis on the need and right of the individual to approach God without intermediaries broke the large communal spirit which was sustained by the Catholic "universal church" where God was approached through rituals in which all society participated and in surroundings where his mystery was symbolized in beautiful and spiritually inspiring objects. It broke, at the same time, the functional position which art maintained in European society as a whole.

Protestantism, rising business enterprise, and individualism did not come into the modern world alone. Along with them came science and the scientific spirit. The new religious views provided for the growth of that spirit by releasing man from his subservient position to orthodox churchly law which had attempted to define not only God's reality but common earthly reality too, even the reality of economic transactions and scientific experiments and deductions. With the growth of scientific attitudes there came in time the right to question God, even eventually the right safely to deny his existence. Thus God's reality in the new free and increasingly scientific and mechanical world devoted to physical invention and business enterprise finally received only a perfunctory Sunday gesture. It, like art, was no longer really believed in. The reality of science was substituted for God's among those who were building the substance of the modern world. God's and Plato's mystic realities both went down the drainpipes of neglect in the new laboratories where precision instruments were extending the areas of man's perception. It was Plato's pupil Aristotle, in

spirit if not actually in a mechanical sense, who was now in intellectual harmony with reality. Aristotle took over that realm from which the Catholic Church, although it had turned his conclusions about the physical world into sanctified dogma, had excluded him. As a devotee of scientific classification, even though without the accurate measurements of modern science, it was he rather than Plato who best pointed the way to ultimate truth, to final reality, in the new world. The difference between Plato and Aristotle in the orthodox Catholic sense, and in a practical sense as well, is perfectly expressed by the artist Raphael in the great Vatican fresco "The School of Athens." In this famous work Plato points upwards to heaven, Aristotle down to the earth in a gesture prophetic of what was to occur in man's new search for reality.

In contradiction to Plato, Aristotle, as Raphael suggests, tied reality to physical existences. For him there was "no form without matter," no reality, that is, of a purely conceptual nature. Concepts became realities only when they were perceived to exist in material forms. How could ideas of things exist if they did not somewhere take tangible shape? They could not exist in the apparent Aristotelian answer, and could not even be accepted until a tangible shape was found for them. This is the modern scientific view, where concepts become realities through objective experimental verification. By bringing reality back into the physical world, into that world of perception on which art, as Plato correctly saw, is almost wholly dependent, would it not seem that art would stand to gain? In a world convinced that reality lay in material substances, would it not seem that art, which deals, primarily, with such substances, could reflect the truly real?

At first glance it would appear so. Certain it is that the secularization of art in the late fifteenth and in the sixteenth centuries produced both a greater perceptive realism and a greater popular belief in the spiritual adequacy of that realism than had existed since the days of the Greeks. Painting in particular, with its new and scientific perspective knowledge, with its

enlarged grasp of the elements of spatial composition, openly asserted that its reality was equal, if not to God's, at least to that of the priests and fathers who interpreted and protected God's reality. And many of these priests and fathers, grown at this time into wordly lovers of the substantial beauties and powers of life, agreed. There was, however, a limit to art's power to encompass the new world. The reality of physical substance, which took the place of God's and Plato's reality, turned out in time to be just as removed from appearances. Whether the world moved around the sun or the sun around the world could not be ascertained from art's reflections, no matter how extended its new techniques. Art could advance in the first substitution of a physical for a spiritual reality, and did advance, especially in painting, to the very heights of historic accomplishment; but it could not follow as that physical reality retreated further and further from the grasp of common perception and became a matter of celestial mathematics and microscopic laboratory tests. Today, with the last advances of physics in mind, art has a lesser claim to represent what is ultimately real than ever in its history. It cannot even pretend in the Gregorian fashion to stand as a symbol thereof.

How then can we account for art's modern survival and, beyond, for the apparent rise of interest in it here in the scientific and mechanical United States? With our inheritance of Puritan individualism and material practicality, both of which denied art from the beginning, and our long and utter devotion to the belief that what was worth most for man's daily life lay in money-making and scientifically produced and directed mechanisms, how can we account for our current attention to art? We can only account for it by the fact that both Protestant individualism, with the bald egotistic and often grossly perverted practicalism accompanying it, and science, with its experimentally verified truths and high-speed machines, have failed to make a world in which human beings, even in this rich land of America, are really at ease. Unconsciously perhaps, but with

growing emphasis, man is asking in America as elsewhere, "What is the human use of a reality you cannot see and feel with your senses or of the practical mechanisms therefrom derived which destroy as much as they produce and throw, in addition, a perpetual shadow of fear over the world?" "Have we gained," the query goes, "by substituting for God's realities those of science, which, for all they produce in the way of practical mechanisms, end up finally with an empty and humanly meaningless space-time in the ultimate void of which the human spirit becomes a mere spurt of electrical energy, a nothing from nothing, destined to nothing? Have we gained when we substitute for Plato's dream of a world under the authority of mystic philosophers a world apparently destined, in large part, to fall under the authority of brutally materialistic dictators, who in the name of science and man's future salvation on earth are willing to turn the present earth into a slave camp? Can any form of practicalism cure the social evils which have accumulated in our Western world since the Protestant release of the individual soul from the communally shared spiritualities of the mother Christian Church? For all of its own evils, this Church with its ancient experience of humanity was a spiritual check on man's apparently innate tendencies toward violence and divergency. Even today, with most of its spirituality gone, with the creative impulse to expression in art that was a significant part of this spirituality gone, too, the memory of its once unifying force persists and sets up yearnings in the thoughts of modern men who remember that in its best days the Catholic Church provided both unity and a large personal freedom, and beyond that a sense of design and purpose in the universe which, if scientifically illusory, had at least a generally comprehensible human meaning.

Contrasting the memory of a religious world with the world of the modern scientist, man finds himself in a questionable position. Insofar as his human self is concerned, science offers no reality at all, only a world of mysterious happenings, some vast, some minute, but in their infinite expansions and

regressions all ultimately beyond the reach of human meaning. God's heaven and Plato's realm of ideas, however abstract they could become, were of the human mind; what reality they had was a human reality. The facts of science, if they are indeed facts, are from outside the human mind and can be grasped by that mind only in a very partial way. They have human reality not in themselves but as their movements set up perceptible activities in the material substances about us. Beyond each of science's facts are others, infinitely strung out, apparently, and in the end beyond observation or the power of man's comprehension. The long scientific search for truth has ended with the discovery that there is no truth outside the human mind itself. We are perhaps seeing the end of an era, the end of a long blind confidence in scientific progress. We are learning again, perhaps, that what is valuable for man, what is meaningful for him, what is hopeful, is not in the outside world but in himself and that man's salvation lies ultimately in wisdom about that self rather than in knowledge of what is outside of it!

Men of science themselves have lost their assurance of yesterday. Some of them are even prepared to go back to God's realities as more dependable than their own. We are in a time of confusion, of soul-searching and doubt. In this welter, men all over the world are turning backwards into the past for solutions. They are turning back to brute primitive force, on the one hand, and, on the other, to some of their ancient humanities. Among these latter the simple human realities of art loom up. They are a natural refuge for the human spirit even in practical and overmechanized America.

I have attempted to show how Plato defined art and why he and his various brother moralists of later times repudiated it. I have touched upon the views of his successor Aristotle, but not specifically with regard to a definition of art. Aristotle added very considerably to Plato in this matter. The creative and formal character of art's reflecting instrument is implicit in Plato's picture. Form was, as a matter of fact, an inescapable

factor in Greek thought about anything. The word for "idea" was synonymous with "form"—an idea was *form*, a concept was a *form*, and in no important way different in accepted parlance, so Greek scholars say, from the *form* of a statue or a chair. Thus, necessarily, the Platonic reflective instrument that was art must, like the potter's vessel or the very treatise of the *Republic* itself, exist through form.

But in spite of Plato's inescapable linguistic recognition of the formal nature of art and the creative acts involved, it was Aristotle who brought these factors clearly into the open. Aristotle accepted the Platonic view that art was imitative and reflective, but he knew there was more involved in the act of reflecting or imitating than Plato admitted. Art might be a mirror, but it was a peculiar kind of one and one which had to be recreated for every new reflection. Plato, allying art with the handicrafts, saw it as a fabrication, but he failed to elaborate on the very special character it had as such. It is in Aristotle's consideration of the art of tragedy that we find the full story. Although there is a tendency among some thinkers today to minimize its importance, Aristotle's *Poetics* gives us the first complete and unbiased picture of art as art. While experience has shown the *Poetics* cannot be used as any rule or formula for creating art, it does, by considering the formal, relational aspects of action, character, and plot in tragedy, set art up in its true constructive and creative character. Aristotle made it clear that a creative act had to be performed before reflection of any kind was possible. He saw that art was not a *passive* reflection of something, as Plato seemed at times to believe, but a creative *act of reflecting* through orderly constructions. Invention, composition, the necessity of establishing an objective unity in the variety of both material substances and reflected perceptions involved, took their true importance. Although the *Poetics* deals primarily with a literary and dramatic art, it states the case for all art. It establishes the primacy of created form in art's kind of reality.

Aristotle objected to Plato's moral condemnation of the

arts. Art has nothing to do with moral lessons, he intimated, but exists on its own plane and must be accepted for its own functions. Its purpose was to reveal man to himself by representing his human perceptions with their accompanying passions and emotions. It did not corrupt the soul, as the moral Plato had it, but sensitized, cleansed, and gave pleasure to it. With all this acceptance of art and clear understanding of its processes, Aristotle nevertheless accorded it a final meaning which has led, in its various adaptations, to much theoretical obscurity.

In opposition to Plato, who said that art reflected only particular appearances, Aristotle said that what art really reflected was the eternal and universal of which these were but parts. This is a large order. In a certain sense it is true, as we shall see, but it is not true in the sense in which it is generally taken. It is a part of Aristotle's general conception of the nature of things, of his system, to which his aesthetics, naturally, must needs be fitted. And yet, taken as it is, it is a strange fitting, because, again in opposition to Plato, Aristotle's conceptions of the true and real lay in the concrete actuality of things. The substance of the real was to be found in the reality of concrete particulars and not in any fuzzy realm of untouchable ideas. But there was nevertheless a univeral reality which existed in the overall form of things. This reality, to put it roughly and perhaps not with the philosophic accuracy demanded, was not to be found in any of the particulars of perception, however concretely and primarily real, but in a sort of summing up of such particulars. The final reality of an organism was in its total life. A man could be grasped as a full reality only by grasping the whole of his progress from the womb to death. He was a "real" man at no one moment of his career but in the total series of actions, "becomings," which his career provided. Now, though this kind of ultimate reality has a more practical common-sense sort of character than Plato's, it would be just as far beyond the power of art to imitate or reflect. No picture or statue or poem could be fashioned which would cover the totalities involved.

What Aristotle really means when he states that art deals in universals can possibly be pictured as follows. A sculptor makes a statue of a particular man. This statue progresses by the organization, the unification, and arrangement of a number of particular perceptions and processes and materials until it ends in a form quite distinct from these. As a form it becomes a thing, quite possibly valuable in itself, and has a reality which is entirely independent of the particular man who was its model, whose existence it set out originally to reflect. Its reality can persist when the particular perceptions it was built upon are gone. It can represent *man* just as well as *a man* and can do so as long as it holds together. It can also represent God's perpetuity, if God is envisaged in the image of man. The Apollo Belvedere is the eternal Apollo. He is also universal and timeless young man. He is this primarily through the permanence of his form. Art's universality lies, then, not in the reflections on which it is based, which are necessarily subjective and particular, but in the form which encloses these. Even this form, however, is a particular in the overall history of forms and depends on its particularism for its distinctive place therein. This picture of art's universality fits Aristotle's metaphysical dictum that "form" and the particularities of "matter" are inseparable, and it is also in line with the plain fact that works of art, whatever "universals" they carry, are different from one another.

In spite of their divergent views as to its social value, both Plato and Aristotle indicated that art was inseparable from direct experiences in the flow of life. The reality of art for both comes into being by reflecting such experiences. Thus, no matter how universally valid the form of art becomes, it must have its origin in some particular, and of course vivid, perceptive responses. These responses, although they are by necessity private, must be capable of possessing a public meaning when they are enclosed in form. Otherwise the work of art will fail to affect, move, cleanse, or entertain. Nowhere in ancient thought is it assumed, as in our modern, individualistic world, that the artist works for himself. He produces, in the classic sense, to affect

others. He mirrors the world that his brothers may see its wonder. He has, for good or evil, a social function. He has, with Aristotle, almost an innate responsibility to the social culture in whose midst he creates. The nature of his perceptions, however private, are largely determined by his cultural surroundings. Greek art must be Greek, not barbarian. The meanings which his forms enclose are thus cultural expressions, although, because they are essentially human, they may find validity beyond the culture of their origin. Greek art has a universal value, but the realities of experience which promoted it were Greek experiences, held within the locales of Greek culture. This kind of localism is true of all great art. Art's reality is based upon the particulars of socially conditioned experience, even though the form this reality takes may be universally valid. Current aesthetic speculation tends to overlook this fact, but it is exceedingly important for the creative artist, who must find himself in the culture to which he belongs or never find himself at all.

Modern science—with its demonstration of the universality of its methods and findings, plus a growing sense among intelligent people everywhere today that something parallel to "scientific universality" must be found in the political world if man is to survive the curse of his new scientific instruments—has given to the word "universal" a significance reaching far beyond its place in philosophy or art. Universal man is no more quite a philosophical abstraction. He is something to be attained in a practical world of things and operations. Universal democracy looms up in the distance, a far distance yet, as a potential. As the conception of universality takes on the color of a political reality it draws attachments and allegiances which are impregnated with strictly political emotions. National sovereignties, national aspirations, isolationist tendencies, localisms of any sort, while they are in fact everywhere adhered to, yet have a suspicious odor in the frame of world ideals. The particularities of nations, peoples, races, are seen among idealists as stumbling blocks to "progress" and universal peace. All particularities, seen

against man's new dreams of an international and universal parliament of man, are suspect. The particularities even of art, and of artists too, have been given a bad name among thinkers who participate in the dream of world unity.

All of this, while commendable from an overall human viewpoint, has adversely affected art by leading it from the only realities with which it is equipped to deal, the realities of ordinary emotionally enveloped and environmentally conditioned human perception. Without these realities the very universalism advocated for art becomes a kind of empty pseudo-scientific process, a process which gets nowhere and gives nothing except to a few cultists who are devoted to process for itself or for the strictly private energy releases it may occasion. A true and lasting art, which is capable of moving men and meaning something to them, is the outcome of responses to particular things, events, and situations coming up in the actual flow of social life. Man does not live alone and remain man. As a matter of fact, he is man rather than beast mainly through his social relations, through being part and parcel of a society, and through sharing the meanings of that society. The artist's responses, essentially private as they must be, even when conditioned by social beliefs and socially shared habits, are through art turned into public forms which, if distinct enough in objective character and poignant enough in human appeal, may become universals. But these forms must originate in emotionally charged responses to the particulars of life. It is there that they get their distinction, their poignancy, and their reality. One does not love woman, but a woman, at least when the love is actualized and made capable of objective demonstration. One does not find the beauty of a flower in the knowledge patterns of botany, which alone can give a scientifically true "universal" of the flower, but in the sensuous patterns of the flower's immediate existence. It is this kind of particular and immediate existence which establishes both significant art form and the reality it encloses. The emotional savor of existence is the only reality art reflects, even though in the sublimations of its form it creates new paralleling

realities which generate new savors. Thus, it is on the base of an immediate emotion-arousing perception of the concretely real, in time and place, whatever that may come to be in universally acceptable form, that art finally depends. Hokusai's famous wave is a universal wave perhaps, but it came out of the sea of Japan, just as Raphael's universal madonnas came out of the face of Renaissance Italy.

Art's reality is then, it appears, a very simple reality. If you are a bigoted and rigid Puritan, a thoroughgoing Platonist, or a strict modern scientist, it is no reality at all. But insofar as our common humanity is concerned, it is a very important one.

The sap of life is found and savored in its daily flow. Passionate love, when it is truly real, is not an *idea* but a *feeling* attached to a particular existence and attached, among other things, to that existence's outward and sensible manifestations. You may love with your soul, if you please, but unless your love is attached to a living male or female, you are missing the heart of things. Man is man, tied to the soil of this earth, and while it is true that he cannot live by bread alone, bread he must have to live at all. He must find his nourishment, even the larger part of his spiritual nourishment, in his responses to the things and situations of the world of his sensible being. The only certain value of life, as the German Goethe said, lies in possessing it, in being of it, in feeling its occurrences. The most important thing in life is life itself.

There is no sure indication that life as we know it exists any place in the universe save on the soil of our earth. There is no certitude that once lost, it will ever be found again. Although man looks with repugnance on his utter obliteration and has built up many hopes of escape, considered probabilities are heavily arrayed against him. Although all the savior gods of his religions have spoken of his immortality, man must face the fact that the dream of another life after death is a mystic dream. This, however, does not make it a fraud or a lie, for the urge which occasions the dream is a human reality and gives reality

to the dream. In the same way, God becomes real and true. God, either in his single or multiple forms, is as real, nay more real, in a human sense than the "realities" of physical science, to the search of which we moderns are now so devoted. These latter, as before noted, are out of the realm of our direct experiences. The realities of God have been and may be directly felt, just as the qualities of a flower or the vast extensions of a starry night may be felt, or as love for another may be felt.

It is our feeling rather than our knowledge which keeps us in tune with life and lets us savor our participation in its mystery. You must "know" life, as in the Biblical sense you "know" a woman, or your knowledge is without consequence to you and you have lived in vain. It is with the felt realities of our living rather than in abstract descriptions thereof that art finds its place. The reality of art, like the reality of God *when He is emotionally actualized*, comes from within our own human selves.

Such difficult intellectual subtleties as ultimate reality and truth came late to man. They are not, considering the full span of his years, very ancient inheritances or very important in the actualities of his daily life. This daily life was lived and fully expressed in the forms of art long before philosophers began logically ordering their thoughts about finalities. In Greece, art had reached the peak of its Greek evolution before thinkers began dissecting it, condemning it, or providing elaborate excuses for its existence. It had operated generation after generation, and with full success, in expressing and formulating the complex life-responses of the imaginative, intelligent, and poetic Greeks, as well as those of their predecessors in civilization. It had done this by simply affirming the human value of what was and what seemed to be. It reflected the savor of life—not the *truth* of life as it could be logically deduced or scientifically demonstrated, but the taste of life as it was lived. It reflected the illusions of life, too, those dreams which people must always attach to life's palpable existences and which give these emotional richness. What *seems to be* is as real sometimes for

humanity as that which can be proved actually to be—as real, that is, for human emotions. If it seemed to the Greek that Apollo might sit at times in the neighboring oak grove, or that a pretty nymph might be bathing in the cool stream below, or that Zeus and his heavenly companions were feasting above the mountain thunderheads, then there they were, in all their poetic reality, figures of life as emotionally real as the human beings in whose images they were made. Greek art gave back to the Greeks, as Plato said, "heaven and the things which are in heaven or under the earth—and the gods," as well as the immediately concrete, humanly conditioned things which told how the things of dream should appear.

Before art can really enter into the common-sense realities of our practical American world, the American mind must get itself accustomed to the fact that the reflections of art and the forms of art and the realities of art have nothing to do with truth in any scientifically provable sense. Scientifically provable reality is not the reality of art and cannot even provide an atmosphere for art's operations. Greater art was made when men believed the earth flat than after they knew it was round. This fact may be relieved somewhat of its apparent outrageousness if our practical American will remember that even in practical America it is not the verified truth of a proposition, but what is emotionally attached to it, that moves the majority of men to action. These are moved to act, for instance, as Catholics, Protestants, Jews, Republicans, Democrats, Socialists, or as Communists, too, not by any proven or scientifically demonstrated truths, but by emotional allegiances to what seems to be true or right or expedient under the propulsions of their emotions and conditioned belief habits. A little realistic concentration on the actual nature of life, as men live it, may help in excusing the nature of art. A man who has power, votes to keep it. A man who has not, votes to get it. Neither are usually interested in the ultimate truth of things or even whether their votes have the slightest bearing on demonstrable economic and

political crisis which these votes affect—and at times determine —in society as a whole. *Truth in any final or provable sense does not determine the reality of the things by which man actually lives.* Your beloved may not be truly beautiful, but if you think she is, that is enough. God cannot be demonstrated, but about the reality of His existence in human emotions there is no question. Even a denial of God attests Him. Were He only, as some hold, a function of the evolution of grammar, His reality would still maintain itself, because whatever His origin, He supplies an emotionally satisfying answer to the impenetrable mystery of our being. The real content of human life is not yet on the laboratory table. This may be too bad, but it is a fact.

Neither is art on the laboratory table, even though some pretend to believe it to be. Its realities, when they exist, are humanly simple, are very ancient, and are true realities only when they are poignant, suggestive, emotionally compelling, or when they seem beautiful or appropriate or in the likeness of familiar experience. They are the realities of ordinary, if sensitized, human perception. They are not profound in a philosophical sense or true in a scientific sense. But they are deeply real, nevertheless. They are real in the sense that the color of a flower is real, or the configurations of a beloved's face, or the beauty of a child for its mother, or the sacrifice of Christ for a believing Christian are real. They are real when responsive emotions say they are so and are thus of the very bone and blood of man's life which truly exists, let me say again, only when it is *felt* to exist.

With such realities it should be obvious that there must always be divergencies of attachment and value-accordance to the forms of art, and some obscurity in the discussion of art. You may explain and explain, but art will always be what each true lover of art makes it. The reality of art must always rest on the particular reality which each particular human being finds in, or makes of, a particular *form* of art. The social value of art lies in its power to unite men when they discover that their human particularities, different as these may be, wrapped,

as they must be, in private emotions, are united in a particular shared public object. As this social function is extended over time and space, over years and in different societies, art becomes a true universal. This universal is humanly greater than any to be expected of science, because it is permanent and unaffected by the exigencies of progress. It is to be noted also that it has survived many gods!